Contents

CW00544130

SECRET NOTTINGHAM

Frank E. Earp and Joseph Earp

AMBERLEY

First published 2016

Amberley Publishing
The Hill, Stroud
Gloucestershire, GL5 4EP

www.amberley-books.com

Copyright © Frank E. Earp and Joseph Earp, 2016

The right of Frank E. Earp and Joseph Earp to be
identified as the Authors of this work has been
asserted in accordance with the Copyrights, Designs
and Patents Act 1988.

ISBN 978 1 4456 5243 6 (print)
ISBN 978 1 4456 5244 3 (ebook)

British Library Cataloguing in Publication Data.
A catalogue record for this book is available from the
British Library.

Typesetting by Amberley Publishing.
Printed in Great Britain.

Introduction

The Magpie
One for sorrow,
Two for joy.
Three for a girl,
Four for a boy.
Five for silver,
Six for gold.
Seven for a secret,
Never to be told.
Eight is a wish,
Nine a kiss.
Ten is a Bird,
You must not miss.

The old nursery rhyme tells what luck you might have when you encounter various numbers of magpies. The seventh line says that you will have 'a secret never to be told'. Well, we've not encountered any magpies today, certainly not seven, so here are secrets about the City of Nottingham that we feel you 'must be told'.

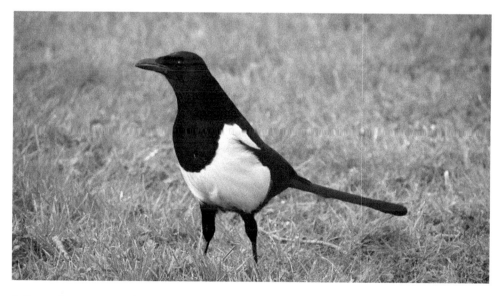

A Nottingham magpie (photograph credit: Nottinghamshire Wildlife Trust).

DID YOU KNOW THAT…?

There is one place in Nottingham City, Meadow Lane, where you are always certain to see plenty of magpies, especially on match days. These are not the avian feathered variety, but the supporters of Notts County FC dressed in their black and white livery. Founded in 1862, Notts County FC is now recognised as being 'The World's Oldest Football League Club'. Although known as Notts County, their Meadow Lane Stadium is actually located within the City limits.

The dictionary defines the word secret in two ways:

'Something that is kept or meant to be kept unknown or unseen by others'

and

'Something not known or seen or not meant to be known or seen by others'.

People keep secrets, so do places, and the city where we live, Nottingham, is no exception. Nottingham is unique, however, in that some of its greatest secrets are kept hidden beneath the very feet of those who walk its streets. What if the streets themselves could talk? What secrets would they tell of people and events they have witnessed? Most of the best of Nottingham's secrets relate to its geography and geology.

As father and son folklorist and historians, we are privy to these and many more of Nottingham's secrets and would like to share our knowledge within the pages of this book. There is, however, one secret we can reveal right at the start: there is more to Nottingham than Robin Hood.

1. Into Nottingham (A Tram Journey)

To begin we thought it would be nice to take the reader on an imaginary journey by tram from one of Nottingham's newest 'gate-ways', the Clifton Park & Ride, to one that is much older, the Midland Railway Station. The significance of the chosen direction of this journey will become apparent in later chapters.

If you are one of the many thousands of visitors who come by car daily to Nottingham from the south of the country, you will have probably used the M1 motorway. At Junction 23, the usual blue sign directs you to 'Exit right onto the A453, for Nottingham South'. From the junction, the A453 passes along the high ground on the south bank of the River Trent, following the line of the river. This is probably one of the busiest roads anywhere in the country and is certainly one of the most ancient. People have passed this way for thousands of years, for the route follows the course of a Roman road dating back at least 2,000 years and possibly a prehistoric track going back even further.

DID YOU KNOW THAT...?

At 8.00 a.m. on 26 October 2014 Britain's war in Afghanistan officially came to an end. After thirteen years of fighting, the war had claimed the lives of 453 British servicemen and women. Early in 2015 work on turning a section of one of Nottingham's busiest roads into a dual-carriageway was nearing completion. By one of those chance occurrences, it was noticed that its designation, number A453, held a great significance for the people of Britain. On 11 March 2015, in a simple ceremony marking the completion of the work, the road was renamed Remembrance Way in honour of the 453 members of the armed forces who died in Afghanistan.

At the point where the A453 enters the city boundary, you will find Nottingham's newest gateway, the Clifton Terminus Park & Ride for Nottingham Express Transit, or NET as it is known. This is the southern terminus of one of the fine new tram lines which now carry the latest in modern electric trams across and around the city (more about this later).

Constructing such a large engineering project across a wide and diverse area of the city gave a chance to explore, in the form of archaeological excavations, something of Nottingham's buried past. This task was given, in the form of what is known as 'a watching brief', to Trent and Peak Archaeology. Particular interest was taken in the Park & Ride site on Lark Hill at Clifton, which was largely a 'green-field' site. Archaeological excavation of the massive 29.6-acre site began in June 2012, after construction workers

had cleared it of topsoil. The archaeologists were expecting to find evidence of Roman or Romano-British activity; however, what they actually found was a prehistoric ritual landscape and evidence of the first human settlers to inhabit a part of what is now the City of Nottingham. The earliest finds were a scatter of 'worked flints' left behind by Mesolithic people sometime around 9,500 years ago. However, these were not settlers to the area, but nomadic hunter-gatherers who roamed the edges of the ice sheet at the end of the last Ice Age.

The first evidence of settlement in the area was a 6,000-year-old Neolithic earthwork consisting of an oval ditch and bank – 101 m north to south and 71 m east to west – with four entrances. It has been suggested that this site is an example of a class of prehistoric earthworks know as a 'causewayed enclosure'. Usually found on such hilltop sites as this, causewayed enclosures consist of an area of land enclosed by between one and four concentric ditches. Soil from the infill of the ditches is piled on the inside to form a bank. The ditches are not continuous, but are broken at irregular intervals by causeways giving access to the interior space and also the name to this class of earthwork. In most cases, together with ease of access, the lack of evidence of a wooden palisade on the top of the banks has led experts to believe that these are not defensive earthworks, but rather a way of defining a space within the landscape. Archaeological finds from within such sites show signs of seasonal activity rather than permanent occupation. Taken as a whole, all the current evidence suggests that causewayed enclosures functioned as gathering places for scattered communities, coming together for ritual and social reasons. Certainly there is evidence on these sites of feasting and possible trade. It has further been suggested that different families, clans or tribes might have been responsible for the cutting and maintenance of different sections of ditch and bank. Aerial photographs of the fields around the village of Barton-in-le-Fabis, in the valley floor below the hill, have revealed a second possible example of them. Does this mean that Nottinghamshire has added two more to the seventy or so known examples of causewayed enclosures in Britain?

A second piece of prehistoric archaeology emerged on the site in the form of a Bronze Age ring ditch some 42.6 feet in diameter. Such earthworks are regarded as indicative of 'ploughed-out' burial mounds often known as tumulus or barrow. Although no remains of burials were found in the Clifton example, certainly its location – on or close to the brow of the hill – and some remains of its central mound, indicate it to be a classic example of this kind of prehistoric funerary monument. There is further evidence of Bronze Age activity, again on the valley floor, close to Clifton Bridge. Here, aerial photographs show a number of ring ditches along the south bank of the Palaeolithic channel of the river.

In many cases features like barrows remained a visible part of the landscape for centuries and were acknowledged by later generations who incorporated them into their own use of the land. This seems to be true of the Clifton example where pit alignments and a section of ditch – possible part of a 'drove-way' and field boundary of Iron Age 800 BC–AD 43 appear to reference the earlier barrow. The discovery of Iron Age activity on the sites shows that by this date, people were genuinely starting to settle in the Clifton area.

Having left the Park & Ride, sitting comfortably on board the tram to Nottingham, you will soon find that the view from the window is of row after row of houses all looking

somewhat alike. This is the Clifton Council Estate – once the largest of its kind in Europe. Designed and planned by William 'Bill' Dennis, the idea for the estate was first conceived in the late 1940s with the planned demolition of the 'back-to-back' slums of the city. The plans envisaged that the estate would be made up of distinct neighbourhoods, each with 600 to 1,500 homes, shops, open spaces and primary schools. This in fact amounted to a complete new town on the southern edge of the city.

In October 1945, Nottingham City Council acquired 936 acres centred around the hamlet of Glapton to the east of the old village of Clifton. However, it was not until 1950 that planning permission was finally granted by the Minister of Housing & Local Government. Building work began in September 1950, with the laying-out and construction of around 25 miles of roads, sewers and other services. By a clever combination of constructing both traditional brick built and the then new concrete houses, an average of thirty homes a week were completed. On its completion in 1955, the Clifton Estate was home to around 40,000 inhabitants.

From Clifton, we go downhill towards the valley floor and with hardly a break, the urban sprawl passes seamlessly into the next village, Wilford. Here it meets the great natural barrier and north–south divide, the River Trent.

When creating the southern extension of NET from Nottingham to Clifton, the builders faced the age old problem of how to cross the Trent. By a clever piece of engineering, the problem was solved without the expense and disruption of building a new bridge. The secret was to cross the river via an already existing bridge, built at a place called Wilford where people had crossed for thousands of years. Like Clifton, Wilford was once a rural idol that has now been swallowed by the city. The early settlement here developed as a

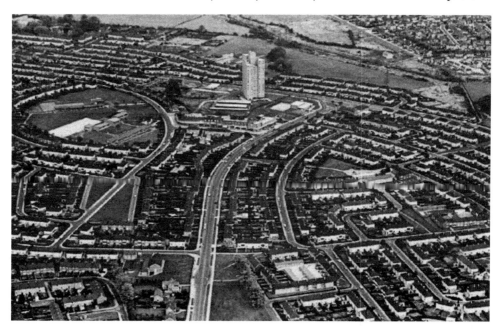

Aerial view of the Clifton Housing Estate, Nottingham, November 1971. At the time of its construction the housing estate was one of the biggest in the country (photograph credit: *Nottingham Post*).

DID YOU KNOW THAT...?

The Clifton Estate features in the 1958 novel *Saturday Night and Sunday Morning* by Nottingham author Allan Sillitoe. At the end of the story the main character Arthur Seaton and his girlfriend Doreen, visit the estate still under construction, to view their future home. In the 1960 film adaptation of the novel, Arthur, played by Albert Finney and Doreen, played by Shirley Anne Field, are seen sitting on a grassy hillside overlooking half-built houses. Because the Clifton Estate was already completed at this time, the scene was recreated on a film-lot in Wembley, where Nottingham builders, Simms Sons & Cooke had set up a staged building site on location.

village divided by the Trent and takes its name from a combination of the name of its principle founder and the ford connecting the two halves. The Domesday Book of 1086 lists the village as 'Willesforde,' literally translating as 'Willa's ford'. When the pagan Saxon population of the settlement were converted to Christianity, a new parish church was built on the south bank close by the ford. This was to enable people from both sides of the river to come together in worship. By a simple confusion over the origin of the name of the village, the new church was dedicated to St Wilfrid. Legend has it that this Northumbrian saint had himself baptised by the good folk of Nottingham at a spot close to the ford.

In the summer of 1900, water levels in the Trent were low and a paved ford bounded by oak posts, believed to be of Roman origin, was revealed. It is now believed that this paved

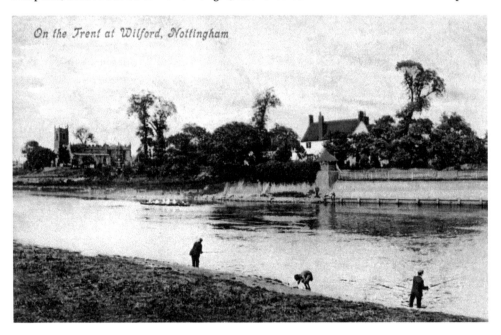

On the Trent at Wilford, Nottingham

An early rural scene along the River Trent at Wilford, Nottingham (photograph credit: The Paul Nix Collection).

crossing was itself built over a prehistoric ford. Perhaps it was used by the Neolithic people to drive cattle to and from their causewayed enclosure back at the Clifton Park & Ride?

For hundreds of years people continued to get their feet wet crossing the ancient ford. That is until the sixteenth century when some bright spark decided to use a boat and began to operate a ferry a little way down river of the ford. Edward III gave the ferry royal approval, which proved lucrative for the enterprising ferryman who was also given an alcohol licence for the ferry house on the Wilford side of the river. The ferry house became a very popular resort in its own right and grew into the Ferry Inn.

The ferry boat, a kind of flat-bottomed punt, was originally hauled across the river by a system of ropes and pulleys attached to both banks, later adapted to using iron chains. This made the boat very cumbersome to operate against the fast flowing stream and rather a dangerous crossing for the passengers. However, people from Wilford and other villages south of the river wishing to get to and from Nottingham market, continued to use the ferry rather than walk downstream to the safer crossing via Trent Bridge.

Hazardous as it was, the ferry continued in use for over 300 years. We have no record of how many accidents happened in the early years of the ferry but in July 1784 disaster overtook the ferry and its passengers. The regular boat was out of use and under repair when eleven passengers embarked in the stand-in vessel. A sudden gale midstream capsized the boat. Most managed to cling onto the iron chain and raise themselves out of the swirling flood. However, in the confusion a man on shore mistakenly let down the chain and those clinging to it were swept away by the current. Only five survivors were rescued from the waters.

A similar incident occurred exactly thirty-five years later when in July 1819 fifteen revellers from the Ferry Boat Inn climbed onboard the ferry for their journey home. The chain suddenly jammed when the boat was halfway across. One of the passengers was thrown into the water and drowned. The ferry was linked to another fatal accident on 10 January 1837. A Wilford farmer by the name of John Oakley and two of his farmhands attempted to cross the river using their own boat further upstream. Caught by the current, the boat drifted into the ferry's chain and capsized, drowning all three men.

Ever-increasing traffic using the crossing led to calls for a bridge to be built, and sanctioned by an Act of Parliament in 1862, a temporary wood structure was thrown across the river and the ferry went out of use. However, the Ferry Boat Inn – now served by the new bridge – continued to be a popular watering hole, as it is today. In comparison to those using the old ferry those crossing the newly built, but temporary wooden bridge at Wilford, must have felt reasonably safe. However, with the ferry gone traffic continued to increase, pushing it beyond its safe capacity. By 1868 it was time to be thinking of a more permanent replacement.

The task of paying for a new bridge fell to the local MP, Sir Robert Juckes Clifton, 9th Baronet. In 1868/69 his company, The Clifton Colliery Company, sank two shafts for a new colliery on the north bank of the river, almost opposite to St Wilfred's Church. A new and safe bridge was required for conveying workers and other traffic to and from the colliery. The new bridge, opened to traffic in 1870, was manufactured of cast iron by Andrew Handyside & Co. of Derby. The fine red-brick toll house on the Nottingham side was designed by E. W. Hughes.

The Wilford Ferry, circa late 1800s (photograph credit: The Paul Nix Collection).

DID YOU KNOW THAT...?

A tall statue of the Nottingham MP, Sir Robert Juckes Clifton 9th Baronet, sponsor of the Wilford toll bridge, once stood outside the Midland Station. Following his death in 1869 the statue was moved by the MP supporters and re-erected close by the toll house It was unveiled when the bridge was opened to traffic on 16 June 1870. *Punch Magazine* was later to say of this statue that it had the 'worst pair of sculptured trousers in England'.

The Wilford Bridge Act of 1862 licensed the old wooden bridge, which replaced the ferry, to exact tolls for its use. This same Act was applied to the new bridge and it quickly became known as The Half-penny Bridge from the cost of the toll for a single 'foot passenger'. In 1969, Nottingham City Council found that the passing years had not been kind to the Victorian bridge. Its structure was discovered to be in very poor condition and in 1974 it was declared unsafe and closed to all traffic. In 1980 the bridge took on a new lease of life when the centre span was replaced by a narrower footbridge of steel girders and a reinforced concrete deck slab, becoming a footpath and cycleway to Wilford and beyond. With the coming of NET, The Half-penny Bridge has risen to the challenges of the twenty-first century. Without losing any of its original charm and character, the central portion has been strengthened and widened to 40 feet allowing it to carry a two-way tram system as well as pedestrian and cycle paths.

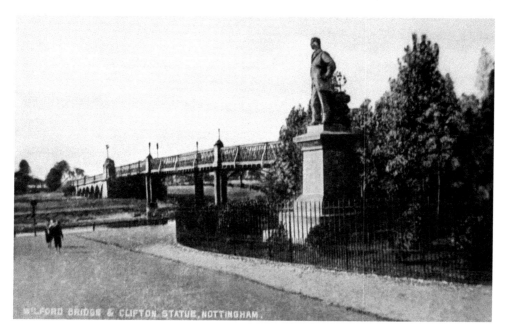

Wilford Bridge and statue (photograph credit: The Paul Nix Collection).

The NET trams are not the first railed transport to cross the river hereabout. Had you crossed the old penny-bridge before 1974 you might have seen trains of the Great Central Railway crossing via a mighty iron bridge and viaduct just a few hundred yards downstream. The bridge and viaduct were demolished in 1985 but the earthen embankment, which carried the track across the open ground on the Wilford side of the river, can still be seen. The GCR started life in 1899 as the 'London Extension' of the Manchester, Sheffield and Lincolnshire Railway. With the opening of this new line, the operating company change its name to better reflect the region through which it passed. At least one railway enthusiast writing on the subject has described the line as, 'Probably the finest railway line that this Country has ever seen...' The London Extension was built for speed; 'Steep gradients, sharp curves and level crossings were studiously avoided and the result was a true racing ground which, had it survived, would have suited modern High Speed Trains to a tee'. Its passage through Nottingham was conducted on viaducts and through tunnels and cuttings all built of 'blue engineering bricks'. With the line's closure in the late 1960s, much of this infrastructure was swept away and now little is to be seen of this massive and expensive engineering project.

Having crossed the bridge, our tram is now on the Nottingham side of the river and passing through an area known as The Meadows. Had we passed through this area 600 years ago, we would have found it to be, as its name implies, a 'water meadow'; a flood plain, which stretched from the River Leen at the foot of the mighty Castle Rock to the banks of the Trent. With the passing of the Nottingham Enclosure Act of 1845, this once beautiful area was to become one of the worst slums in the country. Following the Act, the lush meadows were drained to produce valuable building land for terraced housing, shops, factories and warehouses. Public amenities were not neglected in the planning

and with the development came such buildings as libraries, swimming baths and schools. With the coming of the railway, The Meadows acquired its own station and much of the housing was occupied by railway workers. To cater for the spiritual needs of the population of The Meadows, a new church, St Savior's, was built on Arkwright Walk. Opened in 1864, it remains as one of the few large buildings to survive the wholesale demolition and redevelopment of the area in the 1970s.

As our tram leaves The Meadows and begins its approach to our final destination, Midland Station, it passes a street with an unusual name – Crocus Street. The name takes us back to a time before the area was developed, when in the spring, almost the entire Meadows were carpeted by thousands of crocuses which were harvested for the valuable spice saffron.

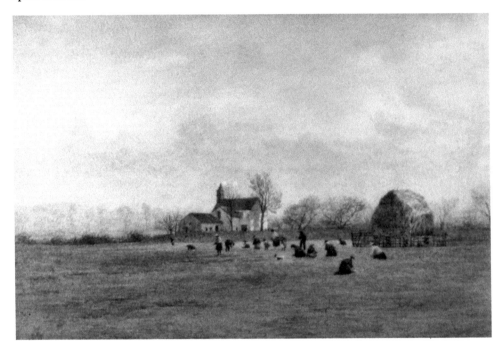

An early painting of The Meadows showing how the area once looked before the Enclosure Act of 1845 heavily developed the land (photograph credit: The Paul Nix Collection).

DID YOU KNOW THAT...?

When the water meadows between Nottingham and the Trent were developed in the nineteenth century, the ancient path which ran from the ford at Wilford remained and constituted one of the few public open spaces. In 1850 the path was formally laid out as an avenue of lime tress and named Queen's Walk to honour the visit to Nottingham of Queen Victoria in 1843. The NET tram now runs along this straight line through the modern district of The Meadows.

2. The River Trent

One of the finest rivers in the world and the most abounding with excellent salmon and all sorts of delicate fish

Izaak Walton, The Modern Angler, 1676.

Standing in the modern city centre in Nottingham's Market Square we are oblivious to the fact that Nottingham stands on the banks of the River Trent. It is not obvious because the river does not flow through the city but rather by it some distance to the south. Without a doubt, Nottingham owes it very existence to its relationship with the River Trent.

The origin of the name of the Trent itself is somewhat complex. The name 'Trisantona Fu' for the Trent, first appears in *The Annals*, written by Roman historian, Tacitus. It has long been considered that Trent is derived from two Celtic words – 'tros' (over) and 'hynt' (way) producing 'troshynt' (over-way). Because of the river's tendency to flood and alter its course, this has been interpreted as meaning 'strong flooding'. In recent years linguists at the University of Wales have suggested that the name is derived from the Romano-British 'Trisantano' – trisent (o)-on- 'through-path' interpreted as 'great feminine thoroughfare'. If this is correct, does it suggest that the river was regarded as a manifestation of a Celtic goddess? One thing it does suggest is that the river was regarded as a busy highway.

Natural History

The Trent is a tidal river. Before human constraints on the river, this tidal influence would have been felt as far as Nottingham. The River Trent is around 185 miles long, making it the third longest river in Britain. For over half its length it flows in a roughly easterly direction. Around Radcliffe-on-Trent it begins to take a more northerly direction and from Newark-on-Trent is flowing almost due north. This alteration in direction happened over 10,000 years ago. Originally the Trent would have continued its journey in an easterly direction and emptied in the Wash. However, sometime during the last ice age a great ice sheet formed in what is now the Vale of Belvoir blocking its progress and causing the river to find a new route to the sea.

A little known fact is that the Trent is one of around 100 rivers worldwide to exhibit a rare natural phenomena known as a tidal bore or aegir. This is a wave or series of waves caused by the incoming tide travelling inland from the rivers estuary against the outgoing current. The Trent tidal bore is known as the Trent Aegir and when conditions are right, produces a 1.5 metre wave which travels inland as far as Gainsborough.

Coarse fishing has always been and still is a popular sport on the River Trent. In good or bad weather, any time during the fishing season between 15 June and 15 March, take a walk along the river and you will see the banks dotted here and there with anglers. Fishing in the river today, it is not expected or possible to catch more than a handful of species

The 'Ancient' River Trent also known as the 'Trespasser' (photograph credit: Joseph Earp).

and certainly only those that the waters now support. Gone is the salmon and Walton's other 'delicate fish'. It was a different matter for the angler of the seventeenth century. A list of species found in the Trent in 1641 gives the names of thirty varieties of fish: barbet, bream, bullhead, burbolts, carp, chevin, crayfish, dates, eel, flounder, frenches, gudgeon, grayling, lampern etc. The sharp-eyed reader might have noticed that one, crayfish, is not a fish but an edible crustacean.

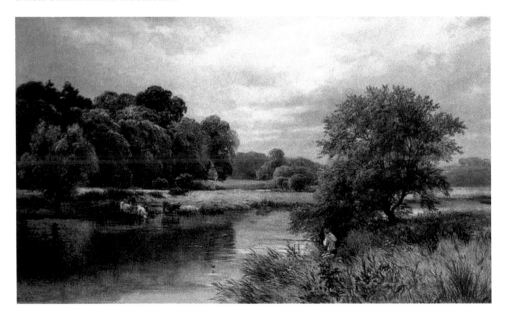

Fishing on the Trent by George Turner, 1850 (photograph credit: The Paul Nix Collection).

Humans and the Trent

Human beings are very fond of imposing geographical boundaries on the natural landscape, but there are incidences where nature has imposed its own boundaries and this is the case for the River Trent. The river flows across the landscape from west to east which acts as a north–south divide cutting Britain into two almost equal halves. Nottingham lies close to the point of what may be considered as the geographical centre of England. The site, on the north bank of the river, is a high ridge of 200-million-year-old sandstone. To reach the north bank, the river was easily crossed using one of at least two fords: at Wilford, and the second, at West Bridgford.

During the last ice age, between 43,000 and 10,000 years ago, when Britain was still a part of Europe, Creswell Crags, a limestone ridge some 30 miles north of Nottingham, was the furthest point north in mainland Britain that anyone could venture because the land beyond was covered by the great ice sheet. Palaeolithic hunter-gatherers used natural caves in the ridge as shelters while on seasonal hunting expeditions. However, this was not their permanent home and in order to reach these base camps they had first to cross the physical barrier of the River Trent. Given the geographical location of the two sites it is likely that they forded the river at Nottingham. It is not unreasonable to suggest that these human hunters were crossing the river at the same places used by their prey and were following animal herds on their seasonal migrations north. Evidence that mammoths once roamed the Trent Valley has been found at Attenborough.

Although sites like Creswell Crags, and scattered finds of Palaeolithic and Mesolithic flint tools, indicate that people have lived in Nottinghamshire and particularly the Trent Valley for thousands of years, there is no real evidence of any permanent settlement

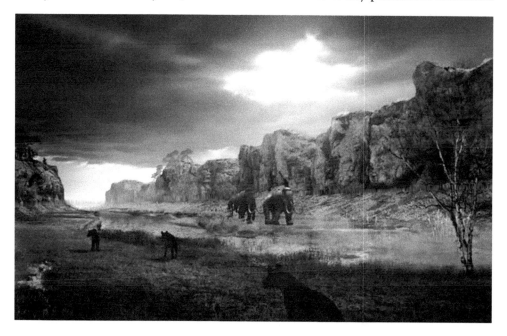

A 3D rendered view of Creswell Crags, 60,000 years ago (photograph credit: The Creswell Heritage Trust).

in the area now occupied by Nottingham due to the nomadic lives of hunter-gatherers. Permanent settlement came in the Neolithic period with the first farmers. Following recent aerial photo surveys of the Trent, archaeologists have made the comment that, 'there are more pre-historic monuments in the Trent valley than in the whole of Wessex.' With the recent discovery of two such monuments at the Clifton Park & Ride site, can we only now say for certain that people have lived and died in Nottingham for thousands of years.

Evidence that people have not only lived alongside the river, but actually over the river, comes once again from the waters bellow Clifton Hall. In 1938, workmen from the Trent Navigation Company were dredging gravel in the Trent below Clifton Grove when their progress was stopped by wooden stakes driven into the riverbed. Human remains, in the form of a skull and bronze spearheads, were also brought to the surface. From the remains and artefacts, the chairman of archaeological group Thoroton Society Hind identified the site as being a 3,000 year-old Bronze Age pile settlement – a village on stilts. Following Hind's brief analysis of the site gravel extraction, and further work on the riverbank continued. Over the period of the next few months several hundred stakes emerged, along with more artefacts. Although the main site was found to be on the south bank, the Clifton side of the river, a large number of piles were also discovered on the north bank, the Nottingham side. These piles were grouped close together and would have supported a platform upon which huts would have been built. The discovery of two dugout canoes, each made from a single oak over 27 feet long and between 18 and 20 inches wide, showed the inhabitants of the village were truly at home on the river. However, Hind's report contains nothing on finds indicating what everyday life on this site would have been like. Among the finds were spearheads, bronze swords, rapiers, daggers and knifes. Hind attributes this large number of weapons to the fact that some form of battle had taken place close to the village. Modern archaeologists however are more accustomed to finding

Some archaeological finds from the Clifton Pile Settlement (photograph credit: The Thoroton Society of Nottinghamshire).

such bronze weaponry deliberately deposited in watery places and now call them 'ritual deposits'. Perhaps the strangest of the finds recovered from the river, were the human skulls – six in total. Each of these had sustained the same damage, a hole in the back of the head. It is likely that these unfortunate people were murdered. Could it be that they were the victims of ritual sacrifice, perhaps an appeal to the god or goddess of the river for safe passage?

Legends and Folklore

Before we leave the River Trent, the reader might like to hear a little of the folklore surrounding it. Here we will focus on the tales relevant to the stretch of the river which flows through Nottingham.

Perhaps the most macabre story relating to this stretch of the river, is that from Trent Bridge to Clifton, there is a tradition that: 'The River must take four lives a year before it is safe to cross'. Can we say from this that the Trent was once a dangerous river to cross or is there a more sinister origin to the Nottingham legend? Is it possible that the human skulls found in the Trent at Clifton, are those of sacrifice victims, ritually murdered and cast into the water to placate an angry river goddess? If this is correct then the four deaths may correspond to one victim for each of the four ancient divisions of the year.

Another piece of local folklore focuses on the origins of the Goose Fair, which is believed all started with a fisherman on the banks of the Trent. It was market day in the town of Nottingham and to escape the hustle and bustle, one of the town's aldermen had decided to take his rod and go fishing on the Trent. After a while he caught a large eel. As he tried to land the fish, which had wrapped itself around his line, a great goose flew down and snatched the eel up in its beak. The man was so surprised that he forgot to let

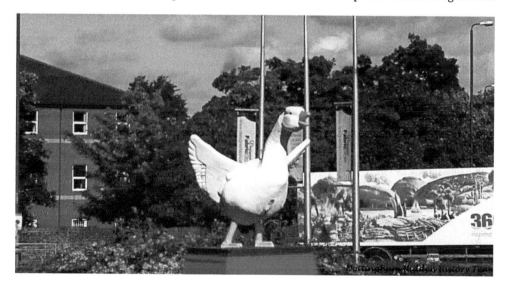

The goose has now become a popular image for Nottingham City Council to promote Nottingham's famous fair. This goose is placed at the start of every Goose Fair at the traffic island close to the Forest Recreation Ground. The goose on the traffic island has become a popular custom in its own right over the years (photograph credit: Joseph Earp).

go of his rod. Up into the sky went the goose and at the other end of the line, the man still clutching his rod. As the goose flew over the market place, the alderman called out for help. Recognising his voice the crowd looked up in amazement. At that moment the goose grew tired of his heavy burden and released the eel from its beak. Down fell the eel, rod, man and all, but instead of crashing to earth, amazingly he landed in a pile of straw set aside for cattle bedding. It was decided that from that day forward, an annual market called the Goose Fair, would be held to mark the occasion.

3. Snottingham to Nottingham

Early History

In the last chapter we learnt of the Bronze Age people who built their home on a pile settlement over the River Trent at Clifton. Although this area is now within the City of Nottingham, it cannot be counted as the beginnings of the settlement or town we now call Nottingham. Although there is no evidence of Bronze Age settlement in the city, a large Bronze Age metalwork hoard was discovered in Great Freeman Street during road maintenance work in 1860. This kind of collection is often regarded as being a ritual deposit marking some form of special place, like the grave of a noble or tribal leader. The hoard, contemporary to the same period as those found in the Trent, consisted of ten socket axes, four bronze arrowheads and a set of bronze rings which are believed to have fitted over a wooden staff.

One particular site rich in Iron Age archaeology is around Halifax Place. The oldest evidence for occupation are a number of pits cut deep into the soft sandstone rock. Pottery shards found within the pits have been dated to the late Iron Age, (750 BC to AD 43). It has been suggested that these are the scant remains of a grain store belonging to a farmstead. Evidence shows that from this time onward the area around Halifax was continuously occupied until 1350 when buildings here were demolished to make way for a garden and not replaced until the eighteenth century. If this is the case, although not part of the original settlement, any domestic dwellings here would have been the oldest houses in Nottingham.

Anglo-Saxons

Halifax Place, the Lace Market, Nottingham, c. 1970s. This is an historical area of Nottingham where a great number of important archaeological finds have been found over the years (photograph credit: Nottingham City Council).

There are some scholars who would have us believe that if history had taken a slightly different turn this book might have been called *Secret Tigguocabauc*. The word, in fact a place name, is of Brythonic origin and is believed to be a part of the first ever written reference to the place we now call Nottingham. However, that is not to say there is any evidence that anyone local ever called the settlement by that name. It is used only once in the diary of a ninth/tenth-century monk named Asser. In around AD 885, Asser was living in St David's (Dyfed) when King Alfred, asked him to join the circle of wise men and advisers he was gathering at his court. Asser accepted the invitation and became the royal chronicler, later penning a biography, *Life of King Alfred*.

The story goes that during one of his many missions on royal business, Asser was on his way to Lincoln, most probably along the old Roman road, the Fosse Way. He records in his diary '... this day passed by Tigguocabauc...' The name has been translated as 'Cavy house', or sometimes 'House' or 'Place of Caves'. In the past, antiquarians and historians have taken this to be the name of a primitive Celtic community living in the caves in the high sandstone ridge on which Nottingham stands. We know now that the eighteenth/nineteenth-century idea that Iron Age or Romano British people ever lived like troglodytes in caves is nonsense. By Asser's time, Nottingham both as a name and a place were already well known. What then is Asser's account really telling us?

The route Asser was traveling is one we still use today, now the A46. The road approaches the modern city of Nottingham from the south, before turning north east to follow the south bank of the Trent. The nearest point it comes to the city is around the village of Cotgrave – 7 miles to the south-east. This then is the closest point Asser's party would have passed his Tigguocabauc. Although he would have been some way off, the wide flood plains would have put little in his line of sight and the sandstone ridge on the north bank – particularly that part we now call Castle Rock – would have been clearly visible on the skyline. It is likely then that his reference is to this place, but why did he call it Tigguocabauc? Asser was a learned man and would have spoken a number of different languages and as a monk he would have written and spoken Latin. However, he was a Welshman and his native language would have been Welsh. Perhaps, from his local guide, there was a chance comment that there were people living in caves there on the other side of the river. This would have been something strange to Asser and in his imagining it, his mind turned to his native Welsh for a description, Tigguocabauc – a house/place of caves.

But this was not Nottingham, or even the beginning of Nottingham. How can we be so certain? The real Nottingham, or Snotengaham as it was known then, began life not around Castle Rock but on the other part of the sandstone ridge on the north side of the hill occupied by the area now known as the Lace Market.

The first thing you should know is that Nottingham was founded by a 'wise man'. That is not to say that he chose the site well or that Nottingham is a special place, although as any 'Nottinghamian' might tell you, both these things are true. No, he was wise because that is what his name 'Snot' means, or a least that is what historians tell us and it is better than the alternative meaning.

Today, our news is filled with (sometimes tragic) stories of migrants seeking a better life, coming to Europe by boat. In the mid to late fifth century after the collapse of the Roman Empire the people of Britannia would have known something similar. These

Caves in the Lace Market, 2012. Nottingham is full of caves everywhere around the city. It is more than likely that Asser in his *Biography of King Alfred the Great* was referring to caves in the Lace Market when he referred to Nottingham as Tiggua Cobaucc, meaning 'Place of Caves', (photograph credit: Joseph Earp).

migrants, who also came to these shores by boat from northern Germany, Denmark and the Netherlands, were a group of Germanic tribes collectively known as the Anglo-Saxons.

Snot, as his name tells us, was an Angle from the Netherlands. Perhaps 100 years after the first migration, he brought his extended family across the North Sea and sailed up the River Trent looking for a new home. The place he found was close to a little river in a sheltered valley on the north side of a high sandstone ridge. The site of this first settlement is now covered by the National Ice Arena. However, because of the annual flooding of the Leen, it would not be long before the new arrivals discovered that this site was not entirely suitable. Inevitably they were forced to move further up the hill nearer the summit.

The name given to this settlement Snotengaham, (later Snottingaham and Snottingham) tells the whole story: Snott – the name of the group/clan as Snot's people; enga, (ing/eng) – water or by the water and ham; – dwelling or hamlet. In around 868, the first recorded mention of Nottingham is as Snotengaham in the *Anglo-Saxon Chronicles*. Snot's little hamlet had grown into a fortified settlement on the rocky high ground to the north of its original site. Archaeological evidence from this period, in the form of seventh/eighth-century pottery, has been found in Fisher Gate. These finds were within the defensive ditch of the settlement, traces of which were discovered adjacent streets, Woolpack Lane and Barker Gate.

By the eighth century, Snotengaham had become one of the royal vills of the Kingdom of Mercia. A vill was an administrative centre of a royal estate. Evidence for this was found once again at Halifax place, in the form of a large timber hall within its own enclosure. That this was indeed an important site is testified by the fact that by the ninth century the building had been replaced by 'bow-sided hall' at least 100 feet long. When, in time, this second hall went out of use, it was replaced by not one but three halls which continued to be used up until the eleventh century. In turn these buildings were replaced around by a large, stone-built, aisle hall. All of these buildings fronted onto High Pavement, once the main road of the Anglo-Saxon settlement.

High Pavement, Lace Market, 2014 (photograph credit: Joseph Earp).

Danish Vikings

From our account so far, which is based on the archaeological evidence, we might believe that this period in the history of Nottingham, was one of growth in settled times. However, history and the written record tell a story the archaeology does not.

In the year 868 an army of Danish Vikings from Yorvik (York), led by a man with the unlikely nickname of Ivar 'the Boneless' (Ivar Ragnarson) forcibly took possession of Snottingaham where they subsequently set up their winter quarts. It is said that over the winter period Ivar and his men fortified 'a strong tower', known as Caesar's Tower, which stood on the summit of the 133-feet-high Castle Rock – later the site of Nottingham Castle. Burgred, the King of Mercia, gave no resistance to this incursion into his lands but instead appealed to his neighbour King Ethelred of Wessex for help.

The following year Ivar's stronghold was besieged by the forces of Ethelred and his more famous brother Alfred (later King Alfred the Great). So great was the strength of the Vikings' position, the Saxons were unable to force a surrender and little if any fighting took place. Ethelred and Alfred were forced to sign a treaty on behalf of Burgred allowing Ivar to keep his conquest on the condition that he made no further attacks on Mercian lands. This agreement was later known as The Treaty of Nottingham but was not to last as it was broken within a year when Ivar had King Edmund of East Anglia murdered while he was staying in Nottingham. Soon after this Ivar and his men very wisely decided to return to York.

The early eighth century saw a change in the tactics of Viking raiders from treasure seeking attacks on the east coast of Britain to one of full scale invasion. By 865, the Great Heathen Army, as the chroniclers of the day called it, had landed in East Anglia bent on the conquest of the Anglo-Saxon kingdoms of England. Having established themselves in the Kingdom of the East Angles, the Great Army turned its attention to the conquest of Mercia. Imagine then the terror of the people of Snottingaham when, in 874, from their high vantage point above the river, they beheld the sight of Viking longships sailing up the Trent on the high tide. It may have seemed that the danger had passed when the fleet sailed on without stopping. Their destination was Repton, Derbyshire, an important

Mercian royal centre some 25 miles up the Trent. However, this was not the last the people of Snottingaham would see of the Vikings.

By the ninth century Mercia had fallen to the Vikings and Snottingaham, as a Mercian settlement, became firmly under their control as a member of the 'Confederation of the Five Boroughs' of Lincoln, Leicester Nottingham, Derby and Stamford. Rather than being a settlement with an urban economy a town, a borough, or burgh was a fort or military garrison and place of administration. The importance of Snottingaham in its role as a borough remained as it always had been, to protect and control the great road to the north and the place where it crossed the river.

Each of the five boroughs was ruled by a 'Jarl' (Saxon Earl) as a Danish 'Jarldom' (Saxon Earldom) who controlled the lands around from the fortified burgh. At first, it is likely that the boroughs were subject to the overall control of the Viking Kingdom of Jorvik (York). Becoming semi-autonomous the boroughs joined together in a political confederation known as Danish Mercia, which in terms of land area covered what is now the East Midlands. As one of the five boroughs, the Jarldom of Snottingaham was now administered under Danelagen (Danelaw), quite literally the Law of the Danes. But so were all of the Saxon kingdoms north of a line running diagonally across the country from London in the south-east to Chester in the north-east.

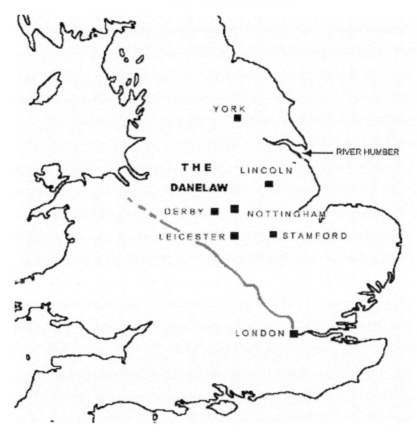

Five Boroughs of the Danelaw (photograph credit: The Paul Nix Collection).

English Rule

It was the King of Wessex (West Saxons) King Alfred the Great, who was the first to style himself King of the Angles and Saxons and began the unification of the various Anglo-Saxon tribes and their kingdoms. But it was to be his grandson Edward the Elder who, after liberating Danelaw from Viking control, would claim to be King of the Land of the Angles, Angle-land (England).

Edward the Elder captured Snottingaham in 924 and immediately began to refortify the old burgh and to build a new burgh on the opposite side of the Trent. To link the two burghs he ordered the building of what was to be the first Trent Bridge. The new bridge also defined the limits of navigation on the Trent and speeded up traffic crossing the river. The building of this bridge was considered so important that it is the only example to be mentioned in the *Anglo-Saxon Chronicles*.

Following the Saxon reconquest of the five boroughs, Snottingaham was to regain its importance both as a settlement and a fortification. Once again the River Trent became the 'great north-south divide' and Snottingaham the guardian of its crossing.

As the Anglo-Saxon Kingdoms slowly became a single entity, so too did the legal, political and administrative systems that were to characterise medieval England. The Borough of Snottingaham was granted its first charters to hold a market in the years 934 and 973, and with this gained town status. By the late tenth century important towns like Snottingaham became the administrative centre of land around it, known as a 'shire'.

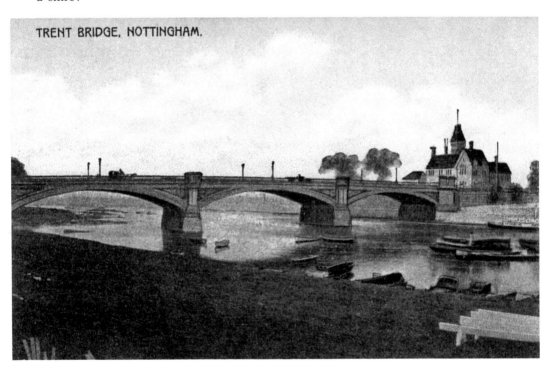

TRENT BRIDGE, NOTTINGHAM.

Old postcard of Trent Bridge. This was the site of where King Edward, in 924, ordered the first Trent Bridge to be built (photograph credit: The Paul Nix Collection).

The Coming of the Normans

Perhaps the most famous date in the history of England is the year 1066. This was the year William Duke of Normandy defeated the King Harold and his Saxon army at the Battle of Hastings. William was crowned King of England in Westminster Abbey on 25 December of the same year.

The new king now faced the problem of all invaders of a foreign country, how do you assert your authority over the land you have taken? William had an army of only a few thousand to control a total population of around 2 million (with perhaps just over 1,000 living in Snottingaham). William had a secret weapon, something the Saxons had not really seen before and something that would change our Snottingaham forever – a motte-and-bailey castle. Castles were useful as they only required a small number of Norman soldiers to control and subjugate the local Saxon population. William spent most of 1067 in Normandy and when he returned to England he found that, using his secret weapon, most of the south was firmly under Norman rule. The north however, was a different matter. The Saxon Earls north of the Trent were showing signs of open revolt against Norman rule and William with a small army rushed north to York to quell the rebellion. There are no prizes for guessing which route he took. Once again it was Snottingaham with its bridge now across the Trent which held the key to the campaign in the north. In a change of regime William had replaced the Saxon Earls who, before the invasion, held land from their king, with his own trusted Norman knights and barons. Snottingaham and its shire was given over to his illegitimate son William of Dover.

Having passed through Snottingaham on his way to York, William recognised its importance as a military stronghold and immediately ordered Peverel to build a castle. The site chosen for the castle was the massive sandstone outcrop now known as Castle Rock. The importance of the castle can be judged by the fact that it was one of only a handful of castles built on the orders of William in the year after the conquest.

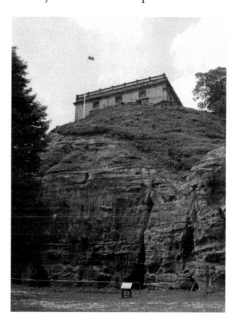

The natural steep hill of Castle Rock was an ideal strategic location to build Nottingham Castle (photograph credit: Joseph Earp).

Due to its location in Nottingham, the 'linchpin of the north', with its natural defences and its close proximity to Sherwood Forest – a royal forest and hunting ground – Nottingham became the favourite royal castle of every monarch from William I to Charles I till its destruction. As such it played its part in the history of our nation.

With the castle came the Norman settlement, later to become known as the French borough as opposed to the English borough, (the original Snottingaham). This settlement grew up around a series of Norman lanes which ran in straight, parallel lines from the castle gate to the new market place William Peverel created in the valley floor between the Norman castle and Saxon town.

Making of a Town

The creation of a new, large, open market place almost exactly between the new Norman settlement and the old Anglo-Saxon town became the thing that united the two peoples. Snottingaham already had its own market place around Weekday Cross at the heart of the town. The story goes that Peverel's new market place was created to solve the problem of frequent clashes with the 'natives' suffered by Normans at the weekly market in the old town. However, this is likely to be an overly romanticised view and the real reason was a central point in which a new town and community could grow. This is borne out by the deliberate Norman town which has its Lanes all running towards the market place. The market place definitely had the desired effect of bringing the people of the two communities together on what was considered to be neutral ground. In turn, this neutral ground became the focal point for the growth of what was to become the city of Nottingham.

We do not know for certain just when the 'S' in the name Snottingaham was dropped. It was probably through a gradual process which recognised Nottingham as referring to the joint Anglo-Norman town, growing around the market. Whenever and however it originally happened we will now drop the 'S' and henceforth only refer to Nottingham, unless talking about the Anglo-Saxon borough.

Nottingham has the unique distinction of once being a town of two halves. Although the physical structures of the burgeoning Anglo-Norman town of Nottingham were joined together around the market place, they continued to be known as the French and English boroughs, each with their own distinct identities. The English borough continued to exists within the confines of the old Saxon defences while the French borough nestled securely between the castle and the common market place. This situation was to continue until a common defensive ditch was built around the whole town in 1300. The two boroughs were also distinct legally and politically, with their own by-laws and civic administration. Throughout the medieval period legal and civil documents still referred to the French and English boroughs. Technically the two halves of Nottingham were not truly united until 1722 when the old town hall at Weekday Cross was moved to the central location by this time referred to as Old Market Square.

In the twelfth century, an earthen defence (bank and ditch) was constructed to enclose both the French and English boroughs in one area. Work began on replacing part of this earthwork with a stone wall around 1260. Extending well over 1 km (0.62 miles) the wall at Nottingham Castle's defences to the west, down Park Row and along Parliament Street to the east. Stone gates controlled the roads into the town at Chapel Bar, Cow Gate, St

John's Bar and Swine Bar. East of Swine Bar the defences remained as an earth bank with a ditch at the front. A wide ditch lay along the front of the wall and an earth bank was heaped up at the back over the lower courses of the wall.

The town's authority considered the wall a necessity after the 'the virtual anarchy of the Barons'.

In the course of the Barron's Wall Nottingham was thrice sacked and burnt. Whether in consequence of these sanguinary experiences, or because it was becoming the contemporary practice, the project of adequately fortifying the town with stone walls and gates was seriously taken in hand.

Stapleton, 1912.

The defences linked the old Anglo-Saxon town and the castle, enclosing the market place on the low ground between the two. There is no evidence of southern defences where the river, marsh and cliff provided natural defences. From this time until the mid-nineteenth century, Nottingham's topography remained unaltered. Much of the town wall had been demolished by 1540. Further robbing of the wall for building stones resulted in its virtual disappearance by the late seventeenth century.

A large section of the town wall were discovered during the construction to extend Maid Marion Way in 1964. After measuring and recording the exposed section it was reburied beneath the development. Another section of wall was discovered during the construction of an underpass on Maid Marion Way at its junction with Friar Lane (one of the original Norman lanes). For a time the section of wall was put on public display in the underpass behind a wire screen. Later, it was shut up behind steel doors where it sadly languished until 2011/12 when the underpass was filled in to create the new junction. Only one small part of Nottingham's original medieval town wall can still be seen in its original position. It is located within a hotel complex close to Chapel Bar. It can be seen behind one of the hotel's ground-floor windows on Maid Marian Way.

The remains are part of the larger section of wall uncovered in 1964. The impressive face of the wall is made of 'ashlar': flat faced and course blocks of local sandstone bonded with mortar. Behind the face is cheaper building materials. This construction method was used to obtain maximum effect for the least cost. Irregular foundation stones at the foot of the face indicate the original ground level. The full height of the wall may have been 26 feet, three times the surviving height), with a path along the top defended by battlements Despite its small size this survivor clearly bears all the history of what happened to this section after the wall was demolished. In one place the medieval masonry is overlain with a nineteenth-century stone wall while in another it is overlain by seventeenth/ eighteenth-century bricks and a floor which project out at right angles to it. These bricks and floor have been left in place to help support the medieval structure.

At the far end of the surviving wall, a stone in the lowest course bears an incised mason's mark which is a simple cross. Each mason had their own style of mark to show who had laid each piece of masonry so that they might be paid for their work appropriately. It is interesting to consider that, as the wall took sixty years to build, a young apprentice mason beginning his first day's work on the site, could have spent his entire working life building just this one wall.

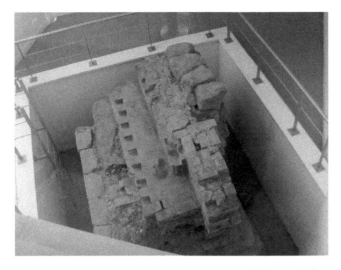

The only remains left of Nottingham's medieval town wall on Chapel Bar (photograph credit: Joseph Earp).

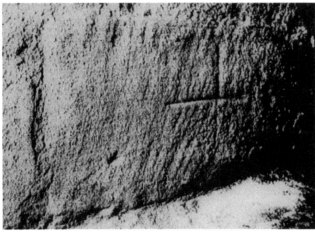

A mason's mark found on the far end of the surviving wall; a stone in the lowest course bears an incised mason's mark which is a simple cross. Each mason had their own style of mark to show who had laid each piece of masonry (photograph credit: The Paul Nix Collection).

Like everything else in the divided town of Nottingham the two boroughs each, for a time, had their own place of Christian worship. The Domesday Book of 1068 records that in 1066 there was 'one church and a priest' in Snottingaham. This church, dedicated to St Mary became the parish church of the English borough and as such is counts as the oldest Christian foundation in Nottingham.

For the people of the French borough it was a different matter. Their part of the town had been built on land outside of the old Snottingaham. This land was one of the many manors belonging to the Saxon Earl Tostig, who William Peverel had displaced. At the centre of this plot stood the Tostig's manor house known as the Red Hall. It was here that Peverel found convenient lodgings while the castle was being built. Next to the hall was the earl's private, stone-built chapel dedicated to St James. One of the first of the five Norman lanes of the French borough, St James' Lane (now St James' Street) was partially constructed as a road to the Red Hall and its attendant chapel. For a time St James became the place of worship for Peverel and those constructing the castle. It is rumoured that King William himself worshipped here on Christmas Day 1067.

As time passed, a suitable residence and chapel were constructed within the confines of the castle walls and Red Hall was abandoned, slowly to decay into the pages of history. St James Chapel however survived and for a time became a moot hall of the Honour of Peverel. The various estates and manors owned by feudal lords like Peverel – who at this time held around 150 villages in Nottinghamshire and Derbyshire – were collectively known as an honour. Courts to settle legal disputes and disagreements between creditors and debtors and those seeking damages for trespass were held in moot halls. Effectively then the new place of worship for the French borough became the chapel in the castle, while the former place of worship St James Chapel became one of its legal centres. The chapel continued in its new use long enough to have a second lane, Moothall Gate, named after it. Although abandoned as a place of worship for many years, St James continued to stand on what was still consecrated ground.

In 1272 a small group of Carmelite Friars (also known as White Friars from the colour of their habit) acquired two plots of land to establish a new Friary between St James' Lane and Moothall Gate. They also acquired a row of houses which bounded their property to the north along the side of Beast Market Hill. The friary itself was a modest group of buildings for the Carmelites who were an order bound to a vow of poverty and relied on begging and charity for a living. Very quickly after the establishment of the friary, Moothall Gate became known as Friar Lane – a name by which it is still known today. The friars were to remain on this site for the next 250 years.

Having acquired this valuable central plot of land the friars were presented with a problem, part of the site was already occupied by a building they did not own. Documents of the time state that they 'found their way barred by the decayed chapel of St James'. For the next forty-four years there followed a protracted 'battle' between the White Friars and the monks of Lenton for ownership of the chapel. In 1308 the friars received permission from the Archbishop of York to dedicate an alter to the Virgin Mary, but this is likely to have been in one of their own buildings and not within the chapel.

Finally in 1316, Edward II signed a deed which transferred to the friary:

a certain plot of land, with the Chapel of St. James on the same plot, in the town of Nottingham, which he, (the King) had of the gift and grant of the Prior and Convent of Lenton, and a little lane leading to the chapel aforesaid, which chapel and lane adjoin the house of the said Prior and brethren.

However, having acquired the chapel, the friars still had the problem of the Peverel Court. Although with the deed of transfer, the court had been moved to the county hall, someone had neglected to tell the kings bailiffs who were still trying to access the site some twelve years later. In 1328 we find record that the bailiffs had made the complaint that the friars had 'enclosed the said chapel with a wall within their house, and so they impede the king's bailiffs of the aforesaid fee, so that they cannot hold court in the aforesaid place'. The dispute was settled and the friars were at last discharged of any duties relating to the court. This then became Church of the Friary, although the original Norman road continued to be referred to as St James' Lane. It was St Nicholas on Castle Gate that was to

become the first 'new' parish church in the mid-twelfth century, followed a few years later by St Peters on Hounds Gate/St Peters' Street.

Nottingham's first royal charter was issued by Henry II in *c*. 1155 and granted the Burgess of Nottingham the rights to: 'Charge tolls on tradesmen who entered the town'; 'Charge tolls on goods passing along the River Trent'; 'Try thieves captured in the town'; 'Hold a market on Saturdays'; 'Have a monopoly on working dyed cloth for a vicinity of 16km (10 miles) around the Town'. A charter issued by Edward I granted Nottingham's Burgess; 'The privilege of electing a Mayor'; 'The right to elect two bailiffs to collect taxes'; 'In addition to a September Fair (later known as Goose Fair), the right to hold a 15 day Fair in November'; However, these privileges came at a price. The burgess had to pay a tax of £52–£60 a year.

Under a charter granted to the Nottingham burgess in 1449 by Henry VI the town was given a degree of civil autonomy. It made Nottingham a corporation, able to govern its own affairs; granted autonomy of the County Sheriff and a county in its own right; the castle and its brewhouse were made 'extra parochial', separate of the corporation; the shire hall remained part of the county. New offices of the corporation were created including a town sheriff, the Sheriff of Nottingham and seven aldermen, Justices of the Peace who elected the mayor from among their ranks. The charter also established new courts of law including a Quarter Session. This system of self-government continued until 1835 when a town council with separate departments was first introduced.

Another great event in Nottingham's long history is when it became a city. In England there is no set criteria, as in other countries, for a town to be granted city status. City status is granted by the monarch on the advice of the government by letters patent normally on special royal occasions. In 1889 Nottingham became a County Borough under the Local Government Act 1888, (the first stage in becoming a city). City status was awarded to Nottingham during Queen Victoria's Diamond Jubilee Celebrations. It was signified in a letter dated 18 June 1897, from the Prime Minister, the Marquess of Salisbury to the Mayor Edward Henry Fraser. Frazer went on to hold the office of Mayor twice more between 1887 and 1899. The newly created city became known as the Queen of the Midlands with its motto *Vivit Post Funera Virtus* (Virtue Outlive Death).

4. Street Tales: If Streets Could Talk, What Tales They'd Tell

The origins of a thoroughfare's name can reveal a great many secrets. These secrets come in all shapes and sizes and can be historic, tragic, amusing, dark and sinister or just plain curious. Here we shall take a look at a few streets in Nottingham with rather interesting origins.

Angel Row

Angel Row runs from the end of St James' Street to the beginning of Mount Street. The name Angel Row comes from an inn called the Angel which stood on the site now occupied the left half of the current Bell Inn. The Angel was once a relatively common name for early inns. As well as denoting a holy winged servant of God, an angel was also an English gold coin introduced in 1465 by Edward IV. Those who frequented such inns would have been aware of this fact and the irony of the juxtaposition of the material and spiritual in one word, would not have been lost on even the humblest of medieval peasant.

Back Side

The thoroughfare known as Back Side from at least 1576, was an ancient road that followed the line of the old medieval town wall. Its name Back Side denotes the fact

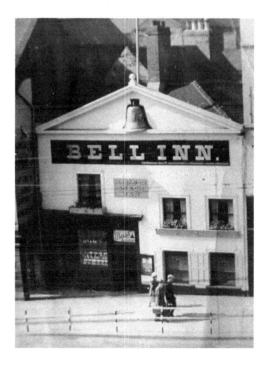

The Bell Inn, Angel Row, Nottingham
(photograph credit: The Paul Nix Collection).

that it was the means of access to the rear of the long narrow strips of properties which fronted onto Long Row. There are at least two explanations as to how it became known as Parliament Street. Both of course involve MPs and the Houses of Parliament.

The first and perhaps the most amusing story takes us back to a time when Nottingham elected its first MP. At this time, the town wall having been robbed of the ashlar facing stones, had disintegrated into a pile of sand and was used as a dumping ground. It was decided that this unsightly area should be cleared and Back Side widened into a new road thus becoming Nottingham's first ring road. But who would pay for such an expensive venture? The new MP for Nottingham was informed that as one of his first duties, he must go to Parliament and ask for a sum of money to clean Back Side. At first he refused, saying that he was not willing to stand up in Parliament and say 'he required money to have his backside cleaned'. It was resolved by him being told that he must inform Parliament that the people of Nottingham required money to clear an area of the town and build a new street called Parliament Street.

The second story tells of the political aspiration of a man called Rouse, who lived in the Angle Row area in around 1770. Rouse was apparently considered by his contemporaries as being, 'not quite mentally normal'. Notwithstanding this he had a great desire to be elected a MP but his wish found little favour with his fellow townsmen. He had a number of boards made bearing the words 'Parliament Street' these he exhibited in various locations around Back Side. The innovation we are told, had no effect on his destinies, but the name struck the people of Nottingham as being more dignified and suitable and has from that day forth been applied to the once humble thoroughfare known as Back Side.

Beest Hill
Originally Friar Row, Beastmarket Hill runs from the end of Friar Lane to the beginning of St James' Street and is one of the thoroughfares of the original Norman borough. The

Parliament Street, Nottingham, 2015 (photograph credit: Joseph Earp).

name Friar Row comes from the fact that the road ran along the boundary wall of the White Friars Priory situated at the end of Friar Lane. It was renamed Beest Market Hill after the priory was dissolved in 1539 when it became the site of the animal (beasts) pens, on market day. Beastmarket Hill is still a busy street at the heart of the city.

Cross Lane

Shakespeare Street formally known as Cross Lane is now famous for the new buildings of Nottingham Trent University and the students that walk up and down the street every day. The street had not always been so grand as its natural position lying in the valley between two gently-sloping hills once made it susceptible to flooding. J. Holland Walker stated that '... it was conveniently placed to collect all the drainage from these hillsides and, consequently, was always notorious for its unpleasant condition. In fact, so bad did it get that it was called Mud Lane'. In 1852 Cross Lane having been tidied up and gentrified, was rechristened Shakespeare Street.

In 1358 gallows used specifically for Jewish criminals stood roughly where the university now stands. The original University College (now Nottingham Trent) was opened on the 30 June 1881 by Prince Leopold. The University College was established on Shakespeare Street to give, 'educational lectures to the Mechanics Institute by University Extension Lecturers'. One famous alumni is none other than D. H Lawrence. Lawrence received his teaching certificate after studying in the Arkwright building. In his novel *The Rainbow,* Lawrence drew on his own memories of the Arkwright building to give its main character, Ursula Brangwen's first impressions of University College, with the lines: 'The

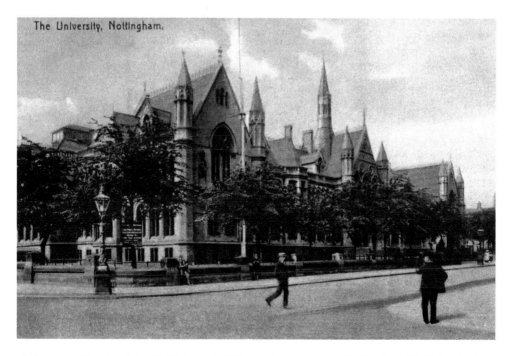

Shakespeare Street and the Old University College (photograph credit: The Paul Nix Collection).

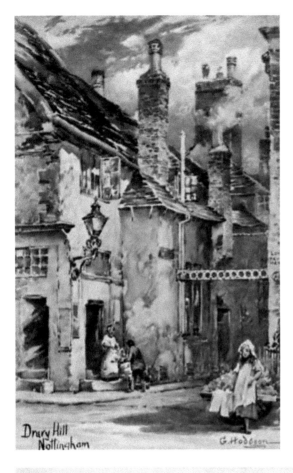

Left: Art postcard showing Drury Hill, Nottingham, by G. Hodgson, dated 1904 (photograph credit: The Paul Nix Collection).

Below: The message describes the scene of Drury Hill which is on the front of the postcard as looking 'ancient'. The whole of Drury Hill was finally demolished in the 1960s to make way for the Broadmarsh Shopping centre (photograph credit: The Paul Nix Collection).

big college built of stone, standing in the quiet street, with a rim of grass and lime-trees all so peaceful: she felt it remote, a magic-land.'

Drury Hill

Without a doubt had Drury Hill not been demolished in the 1960s it would have most certainly rivalled York's very own Shambles as one of the most important and picturesque examples of a medieval thoroughfare in the country. However, this was not to be and despite many protests from all quarters the ancient thoroughfare was removed to make way for the Low Pavement entrance to the then new Broadmarsh Shopping Centre.

Drury Hill, with its narrowness and congestion and its curious haphazard buildings, classically demonstrated just what medieval Nottingham would have looked like. Drury Hill was 4 feet 10 inches wide at its narrowest point and in modern times signs had to be posted to alert traffic to its hazards. So narrow was the road and so great the overhang of its buildings, it was said that in some places people on opposite sides were able to reach over and join hands.

Drury Hill was part of the town's old medieval business thoroughfare through Nottingham which came down Narrow Marsh and passed north along Bridlesmith Gate. Although very steep, the gradient of Drury Hill was slack. To get a good impression of how steep Drury Hill was it is worth going through the entrance of the Broadmarsh Shopping Centre and going down the escalator. It is however, very hard to picture all of the old medieval buildings that were once there compared to the modern shopping centre.

Drury Hill was not the first or even second name of this ancient thoroughfare. Originally Vault Lane, the name was first changed to Parkyn Lane, probably when a member of the Parkyn family of Bunny took up residence in the street. The name was changed again about 1620. The Drury to which the name refers was a certain Alderman Drury, who was

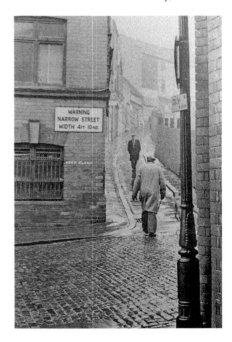

Drury Hill, Nottingham c. 1960s. The warning sign which can be seen on the wall in the photograph was saved and now resides in the Wollaton Hall Industrial Museum (photograph credit: The Paul Nix Collection).

something of a figure in Nottingham in the days of Charles I. He bought the house which faced Low Pavement and which occupied the site of Nos 2 and 4 Low Pavement, under which are the enormous rock-hewn cellars/vaults with a fascinating history, which gave the name of 'Vault' to the Lane.

Drury Hill must have been a very important route in its heyday, for when the town was fortified in Henry II's time provision for a gateway in the town wall was made on the summit. To some the demolition of Drury Hill is one of the greatest acts of civic vandalism ever perpetrated on the City of Nottingham. The only object left today that marks the site is the original road sign which can still be seen on the wall to the right of the entrance to the Broadmarsh Shopping Centre. We can only speculate today what Drury Hill would have looked like today had it been left standing and perhaps incorporated into the centre. What a wonder and experience for both tourist and locals it would have been.

Exchange Walk

At around 73 m long and 4.5 m wide, Exchange Walk is a pedestrian route connecting Nottingham's Market Square and the western end of St Peter's Gate, (St Peter's Square). It takes its name from the Market's Exchange building, which formally stood on the site now occupied by the Council House. Today, Exchange Walk is a busy shopping thoroughfare. With its many leading retail shops and outlets, it is very surprising to know that until 1868, it was little more than a private yard.

Formally known as Gears' Yard the land was part of commercial premises owned by William Gears, a fishmonger operating a stall in Market Square. The premises, on the western side of the yard, were later acquired by James Farmer a draper. It was Farmer who first had the idea of turning the long narrow yard into a pedestrian thoroughfare. Farmer's plans for a route, providing a shorter and therefore quicker access between two important areas of the town, must have met with a certain degree of acceptance from the local authorities and all that was required was the finance. Farmer found his financial bakers in the form of 'Smith's Bank'.

Popular and busy as it is today, Exchange Walk is but a shadow of what was originally planned by Farmer and his financial backers. Although the idea of having a shortcut between Market Square and St Peter's Square was acceptable to the local authorities, Farmer's and the bank's original plan was not. It was envisaged that the new road would be lined with shops and businesses and wide enough to carry both vehicles and pedestrians and would rival most of the city's other major shopping streets. It was perhaps this fact along with objections from retailers and businesses in other areas of the city which brought about the rejection of the plan. Whatever the reason, it is reported that Farmer and the bank were 'greatly shocked at the rejection'.

However, perhaps it is a positive thing that Exchange Walk did not develop into a much bigger shopping lane. The thoroughfare carries a large amount of pedestrian traffic today and thus relieves that along Wheeler Gate. Perhaps more importantly it saves hours of valuable 'shopping time' in acting as a shortcut to the Square rather than being diverted up Wheeler Gate and Bridlesmith Gate.

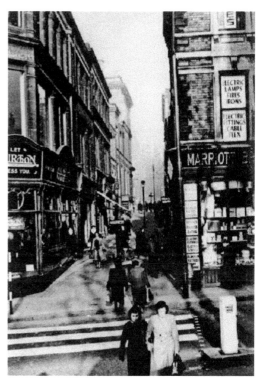

Right: Exchange Walk, Nottingham, *c.* 1950 (photograph credit: Nottingham City Council).

Below: Goose Gate, *c.* 1960s (photograph credit: The Paul Nix Collection).

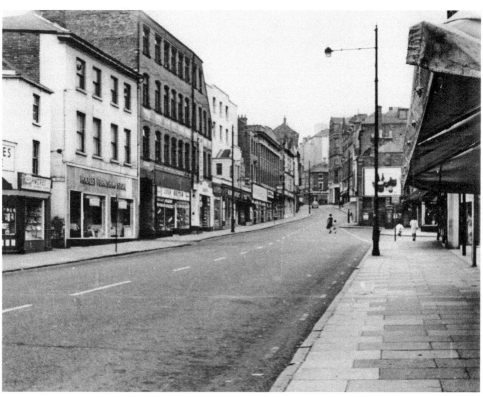

Gos Gate

Goose Gate, formally Gos Gate, is perhaps one of the most celebrated street names in Nottingham. It is said to be the road down which many thousands of geese were driven into the Old Market Square each year at Michaelmas for sale at the Goose Fair. However, this old explanation for the origin of the name is just a charming and romantic tale. From around 1400, the name of the road appears as Gos Gate only changing to Goose Gate by around 1650. It is therefore more likely that the road takes its name from one of its more famous residents Robert Gos, aka Robert le Orfevere. From 1284 to 1448 Nottingham annually appointed two town bailiffs, one for each of the two boroughs. Between 1301–02 and 1311–12 Gos was elected to this important office seven times.

Long Row

Long Row originally no more than a row of tradesmen's counters and stalls abutting the 'Great Market Place' 6.4 acres, but as trade grew wealthy merchants' houses façades were replaced with shops at street level. These merchants' houses grew as did their trade until Long Row was a row of five- and six-storeyed timber skyscrapers, each floor jutting out 1 metre average above the floor below.

This meant that the top floor of the tallest buildings were halfway out over the street. This was fine when the buildings were new. However, in later years when the timber had started to warp and move, the council of the time – not wanting these skyscrapers to crash down into the Market Place – had a problem. From the time of the very creation of the market area a strict law had been passed that no building was permitted on it, but now they were faced with a dilemma. It was resolved by them granting each occupier along the Row two to four (depending on width abutting the market) pieces of land each 70 cm square – large enough to insert the base of a long length of timber, the other end of which was propping up the top storey of their building. These gratis pieces of land were retained when, with the introduction of brick, the buildings were rebuilt; it meant extra floor area in the upper storeys. Even today most of the building facing on to Market Square have a row of pillars supporting the upper floors and giving a nice colonnade beneath for their patrons.

At the Chapel Bar end of the Long Row is the site of the George & Dragon Inn (there is still a modern pub of that name on the spot), the first building in Nottingham to have tiles on the roof. A tale is told of a butcher and his lad staying at the George. He had come for market day to purchase some new butcher's knives, having heard tell of the local smiths' skill. Now obviously the master stayed in one of the rooms on the first floor, but the boy was relegated to the attic for his bed with all of the other lads and servants. There he got talking to another boy, who like himself, said it was his first time out of the village that he was born in and his first visit to a town. The lad listened in disbelief as he was told about the covering of the roof, it being tiles. The butcher's lad could not be convinced; he knew that roofs are covered with reed or straw, not these tiles, so to discover the truth they decided to go up and have a look for themselves.

In the yard behind the inn a long ladder was found and put against the back of the building. It just reached the eaves of the roof, the other boy held the ladder as our butcher's lad climbed it. Once off the ladder and onto the roof he decided, because he thought that

no one in his village would believe him, to take one of these tiles away with him. The tiles lower down the roof would not come loose so he climbed up to the ridge where he slowly managed to extract one; he was so engrossed in this that he did not hear the other fellow call him. Down below the other lad had heard his master shouting, and so that no one should see what they were doing he took the ladder down, calling to the butcher's boy to tell him what he had done.

A tile extracted, the butcher's lad slid back down the roof; on reaching the edge he scrambled down to the eaves expecting to find the ladder, it had gone and so had he – his hands both fully occupied clutching the tile! The other lad never returned, and in the morning, when the butcher's lad was called for and did not come, a search was made for him. He was found in the yard on his back still clutching the unbroken roof tile, stone dead. After some investigation the other lad came forward and told all.

At the other end of Long Row we have the tale of the first recorded mention of braces (for holding up trousers) in Nottingham. A soldier in the Nottingham Militia was staying at one of the inns on the Long Row, and retired to his bedroom. Sometime later smoke

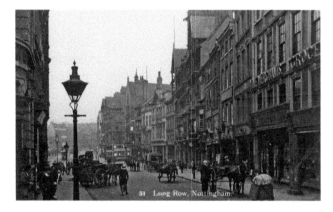

Long Row, Nottingham, *c.* 1890s (photograph credit: The Paul Nix Collection).

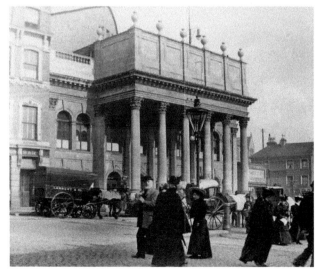

Theatre Royal, Nottingham, *c.* 1899 (photograph credit: Nottingham Historical Film Unit).

was seen issuing from beneath his door. The door was broken in and he was found on the bed, all ablaze. The inquest into this incident reported that:

> He had been wearing these new-fangled braces to hold up his trousers and while trying to disentangle himself from these dangerous devices, he had fallen against the corner of the bedside table, knocking himself unconscious, tipping over the candle, both ending up on the blazing bed.

Theatre Square

Theatre Square is named after Nottingham's Theatre Royal. The theatre took six months to be built at the cost of £15,000 paid for by lace manufacturers John and William and opened for its first performance 25 September 1865. Folklore tells us that on the day of its opening, the theatre was not quite finished and the joiners and painters were still at work when the doors opened to the public. It is said that the patrons of the first performance might have thought it part of the production, as the first performance was a play called *The House That Jack Built*. However, in this case, folklore is mistaken, as the records show that the first performance was a production of Sheridan's *The School for Scandal*.

Toll House Hill

Until around 1855 this part of the old Derby Road was known as Toll House Hill. It takes its name from the toll house – a collection point used to gather the tolls paid for using the road. An item from the Chamberlain's Accounts for 1648–49 includes the following entry: 'Item, paid William Smalley for building the toll house at Chappel Barre (Chapel Bar) £2 0s 6d.' This was around £236,000 in today's money. The toll house was built just outside the old gate (the bar) to the town walls and the old gate itself was not a part of the toll barrier.

How long should such an expensive building last? It seems that Mr Smalley may not have made such a good job or the building was neglected or poorly maintained. Forty years on we find the toll house in a poor state and in need of repair:

> On Tuesday, September 16th 1690: It is this [day] ordered, that whereas the Toll-house on the outside of the barr is falne downe, and the toll-house in the market-place out of repair, that the present Sheriffes shall build up the one, and repair the other, and be repaid by the Sheriffes, onely loseing 20s.; and so the Sheriffes successively loose Tenne shillings a peice, as it was customary, in payment of the Maces and staffes.

Tolls were still being collected, in the mid-eighteenth century, but not everyone was willing to pay. In 1753 records show that a William Birch of Sneinton '... refused to pay toll for his Carriage loaded with goods coming into the Manor of Nottingham by the Chappel Bar'.

The toll house finally met its end on 30 December 1757:

> Ordered that Edward Spurr shall have Liberty to pull down the Toll House on the out side of the Chappell Barr and Sell the Materials for his own benefit he having paid

Tollhouse Hill is still today a busy road into Nottingham (photograph credit: The Paul Nix Collection).

five pounds to Mr. John Foxcroft Chaberlain as full price for the same for which sum Mr. Foxcroft to be accountable to this Corporation.

After the demise of the toll house on 20 May 1761:

... to Joseph Newton, victualler, and Joshua Fox, framework knitter, of a piece of waste ground outside Chappell Bar, near the side of Toll House Hill on part of which the late lessee, Joseph Finch, erected a weighing machine, and on another part of which a new weighing machine has been since placed); for thirty-one years from 25 March last, at a yearly rent of 5s.

In January 1772 it was agreed to repair and widen the road to Derby to which Toll House Hill formed the Nottingham end. In December 1782 the 'Publick (Public) Well', outside Chapel Bar, had a pump fitted at the cost of 12 guineas. An original unnamed road on the hill, which ran up and joined Back Lane (now Wollaton Street) is named on Staveley and Wood's map of 1831 as Toll Street and this still exists today. It is seen to run parallel to Toll House Hill, with both converging on the Chapel Bar Gateway.

5. Nottingham – A Place to Shop

It is no secret that the modern City of Nottingham enjoys a reputation for offering one of the finest shopping experiences anywhere in the country. At its heart is the Old Market Square, surrounded by pubs, cafés, restaurants, department stores and independent retailers of every kind. The Square is also well served by the city's transport network, with bus stops around the perimeter and the NET tramline running along two sides. But that's not all, Nottingham has two premier shopping centres: to the north of the Square intu Victoria, and to the south intu Broadmarsh. However, the real secret which makes shopping in Nottingham pleasurable is that all three are close enough to be able to walk from one side of the city to the other in around ten minutes. So, as the advertising blurb says; 'A trip to Nottingham means more shopping and less walking'.

Beginning with the northern most of these three sites, the Victoria Centre, we would like to take you on, not so much a shopping trip, but more of a hunt for secrets, for each of these sites has its history and stories to tell.

Victoria Centre

Victoria Shopping Centre (now intu Victoria) is just over 200m north of Nottingham's Council House, in the historic heart of the city, Old Market Square. The site on which it stands is roughly rectangular, with its long sides running north south. The centre's visible frontage is confined to the western long side – Milton Street (A60) and the southern short side – Lower Parliament Street (A6008). The main entrance is located at the south-western corner at the junction of the aforementioned streets. A further entrance, dominated by the clock tower of the old Victoria Railway Station, is located around halfway along the frontage on Milton Street.

The centre was the first of its kind to be built in the city. The site chosen was that left vacant after the demolition of the Victoria Railway Station, hence its name. The linear shape of the plot, parallel to the main north–south road, reflects the course of the old

DID YOU KNOW THAT...?

Here then is the centre's first secret. The road junction is known by locals as Lemming's Corner. At the busiest times of the day (and night) it is not unusual to see large crowds of pedestrians who have been waiting at the crossing, suddenly rush across the road as the lights change. In recent years, so bad has the conflict between pedestrian and road traffic become that at peak times crossing guards are now employed to safely escort the crowds across the road.

rail line. Beginning in 1967 the centre took some five years to build and when completed consisted – as it does today – of more than just a shopping mall. For those with a head for statistics, the mall has a retail floor space of 91,140m² over two floors. Occupying this space are 120 assorted retail outlets including many well-known retailers, independent traders, a fitness centre, cafés, and restaurants. On the second floor is perhaps one of the centre's most popular features, a large independent market containing dozens of stalls. Below the mall is its car park with parking for 2,700 vehicles on two floors. At the northern end of the site is the Victoria Bus Station. Paying homage to the former use of the site, the developers saw-fit to include not only the station clock tower as a special feature, but also incorporated the entire building that was formally the Victoria Station Hotel (now operated by Hilton Hotels). Rising above the centre and visually dominating the Nottingham skyline for miles around, are the Victoria Centre Flats. The building rises to the height of 72 m and with twenty-six floors contains 464 flats and 3,300m² of office space.

So how did a modern shopping centre come to be called the Victoria Centre? Quite obviously it was named after the railway station which formally stood on the site. However, although built and first operated in the reign of Queen Victoria, what is not so obvious is how the old station got its name.

Before the days of a national unified railway under British Rail, the Victoria Station was a destination on the lines of two rival railway companies: The Great Northern Railway and with its new line, the London Extension, a newcomer to the region of The Great Central Railway. The two owners of the station could not agree on what to call it. Great Central wanted to call it Nottingham Central, reflecting their interest, a proposal that Great Northern quite simply could not accept. And so it was that the two companies went their separate ways both operating their own booking offices within the station. While the Great Central issued tickets bearing 'Nottingham Central', above the window of the Great Northern office were the words 'Nottingham Joint St'n'.

The front of the Victoria Shopping Centre during redevelopment, June 2015 (photograph credit: Joseph Earp).

DID YOU KNOW THAT...?

The water-powered Emett Clock, also known as Aqua Horological Tintinnabulator ,was designed and created by the kinetic sculptor, Rowland Emett. The clock arrived at the Victoria Centre in 1973. Since its installation it has become a much-loved local landmark and a popular meeting place. Since its first installation the clock has chimed on the hour and half hour, playing 'Gigue en Rondeau II' (1724) from Rameau's (1683–1764), 'Pieces de Clavecin' Suite in E-minor. This musical, animated sculpture was originally situated between Boots, Next and John Lewis (formerly Jessops) on the lower mall of the Victoria Shopping Centre. At some point, the clock was modified to chime and play the music every fifteen minutes.

In 2014 the future of the clock looked grim. There were reports in the media and in the local community that the clock was going to be dismantled and would no longer be displayed in the Victoria Centre. Thankfully this was not true; however, after over forty years at the heart of the shopping centre, the Emett Clock was looking a little the worse for wear. It was dismantled and taken away to be lovingly restored by local engineer Pete Dexter and The Rowland Emmett Society. Over the summer of 2014 the clock was reassembled and went on public display at an exhibition at the Millennium Point in Birmingham.

After it had been on display in Birmingham it was put into storage until December 2014. The parts were then transported back to Nottingham where further refurbishment work was carried out by Pete Dexter. It was then officially reassembled in its new location at the north end of the upper mall in the Victoria Centre. Its stature, colour scheme and most of its original water features were restored. It was officially restarted on 17 June 2015 by Emma Jaggers, granddaughter of Pete Dexter.

So the future of the clock looks safe for now. A common little local custom connected with the clock is to throw a coin into the clock's pond and make a wish. Many children and adults alike have done this over the years and the custom has become very popular among shoppers to the Victoria Centre. All donations are given to local charities.

To confuse things even further the 1898 Royal Atlas of England records the name of the station as the 'Grt Central & Grt Northern Joint Central Station'. All of this proved greatly distressing to the Town Council and in an attempt to resolve the issue the Town Clerk suggested the name 'Nottingham Victoria Station'. This was to reflect that the proposed official opening day coincided with Queen Victoria's birthday. The proposal won the favour of all sides and was duly accepted at a meeting of the Nottingham Joint Station Committee.

In 1893 what was later to become The Great Northern Railway gained permission to extend its operations south to London. A new direct line was built between the village of Annesley, 7 miles north of Nottingham, and London's Marylebone Station with a total distance of 92 miles. Rather than carve a route through the heart of Nottingham the new line entered and exited the town through tunnels only coming to the surface at the new

station. Once again the north of England was linked to the south via Nottingham, along a route which very much paralleled the ancient highway.

The site for the new station lay directly alongside the old north–south highway and in medieval times, would have been just outside the northern gate of the town wall. Costing some £473,000, the strip of land acquired measured 13 acres and running north to 590 m long with an average width of 100 m. To prepare the land for the railway 1,300 houses, twenty-four public houses and a church (St Stephen's) were demolished. The line entered and exited the station through a cutting between the two tunnels, the excavation of which required the removal of 460,000 cubic metres of sandstone bedrock. The scale of the cutting and entrance to the northern tunnel can still be seen from the Victoria Bus Station. However, if you wish to see this amazing feat of Victorian engineering, do so now as it is the intention of the current redevelopment to build an extension which will fill the station's deep cutting and conceal the entrance to the northern tunnel.

Negotiations for the acquisition of the land for the railway took around three years and some compulsory purchase orders were needed. Building work took another three years and when complete the building was a masterpiece of Victorian architecture and engineering. There is of course much more we can say about the station building, but space does not permit and as they say; 'A picture paints a thousand words'. It is also possible to get some imprecision of the station's appearance by viewing the frontage of the Victoria Hotel and the station's 30 m high clock tower.

Without any formality, the station went straight into operation even before the paint was dry on its woodwork. Over a year later, the station's official opening took place, without undue ceremony in the early hours of the morning of 24 March 1900, Queen Victoria's eighty-first birthday. At precisely 1.12 a.m. the first train to stop at the newly opened station was a Great Central express carrying passengers from Manchester to London. Exactly fifteen minutes later it was followed by an express of the same company travelling in the opposite direction.

The Mansfield Road railway tunnel, taken where the old Victoria Station platforms would have been (photograph credit: Mark Bainbridge).

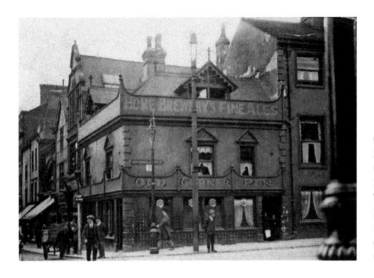

Old Corner Pin, Upper Parliament Street/ Clumber Street junction, Nottingham, 1926. This was the site of Nottingham's original maypole (photograph credit: The Paul Nix Collection).

Of those many thousands of visitors crossing at Lemming Corner, how many know that if they had done so around 300 years ago, they would have countered a Maypole in the middle of the road? Sir Charles Sedly, Bart., Gentleman of Nuthall Temple fame was re-elected to Parliament in 1747. To celebrate his victory it is said that he 'presented his partisans' with the finest fir tree – a larch – in his park at Nuthall, which they erected as the 'new' Maypole. The pole was erected in the road at the lower end of the street, close by the junction of Clumber Street. It is interesting to note that this site was just outside the medieval town walls, opposite the north gate. The use of the words 'the new Maypole' suggest that there had been a previous pole on this site. The pole stood around thirty-three years long enough to have a public house named after it – The Maypole, later The Old Corner Pin, on Clumber Street. In 1780, one of the overseers of the highway, Mr Thomas Wyer, declared the pole to be unsafe and ordered it to be taken down. The only reference to Sedly's Maypole is the name Maypole Yard associated with an alleyway off Clumber Street.

Old Market Square

It has always been reputed that, with the exception of London's Trafalgar Square, Nottingham's Old Market Square is the largest public space of its kind in Britain. At the very heart of the city since the time of the Normans, the square has always been at the centre of life in Nottingham. However, it was not the first site for a weekly market in Nottingham.

The site of the Old Market Square dates back to the eleventh century when there was the English and French boroughs. As an established settlement the English borough had developed a thriving market place with a Market Cross, the Weekday Cross, at its centre. As the French borough grew it did not develop its own market place but instead the Norman inhabitants relied on visits to the Saxon market for trade. Unfortunately there was often friction when the Normans came into the English borough. The Norman 'overlord' and builder of Nottingham Castle decided that to keep the peace it was necessary to create a new market place to be shared by both communities. The neutral ground chosen was a 5.5 acre site in the valley floor between the two boroughs.

Soon after this wide, open space began its role as a market place, it was divided into two halves by a stone wall running east–west, down its centre. There is still a widely held belief among some scholars that the function of the wall was to keep apart the feuding Saxons and Normans. However the true function of the wall is less dramatic and more practicable. In actuality it divided the animal, or livestock market from the grain and commercial market something it continued to do long after the distinction between Saxon and Norman was forgotten. When visiting the Market Square today, it is still possible to get an idea as to what this barrier must have looked like. Between 2004 and 2007 the square underwent massive redevelopment. By chance or design, a stainless steel drainage channel follows the original line of the old wall.

Old Market Square no longer serves as an open market place, but as a traditional public open space, or city square covering an area of some 22,000m². As the largest and foremost public open space in the city, today it is regularly used for events such as fairs, concerts, Christmas markets and exhibitions. Once a year in the summer, a large part of the square is covered in tons of sand as a beach, when the city becomes 'Nottingham by the Sea'.

The word square is a misnomer and is used in the traditional sense only. Covering most of the earlier site of the planned Norman market the square is rectilinear in shape with its long sides running almost east–west. At its eastern end the square is dominated by Nottingham's Council House – site of the old market's Exchange building, (the administrative centre of the market). The western end is bounded by the road Beastmarket Hill, the name of which reflects its former use. The northern long side is bounded by Long Row and the southern side South Parade and Cheapside. These streets along with many others in the area surrounding the Square, still retain names relating to the time when it was used as a market place.

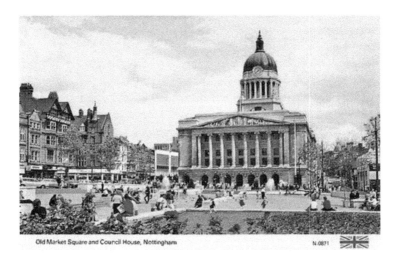

Old Market Square and Council House, Nottingham N.0871

Nottingham's famous Old Market Square (photograph credit: The Paul Nix Collection).

We are fortunate to have a number of documents, descriptions, illustrations and photos, which, when combined give us a good idea of what the old market must have looked like in its heyday. Originally, the whole area between High Street in the east and Chapel Bar in the west would have been open space. On market days the High Street end was the site of the shambles where the town and country butchers displayed their meat. It is interesting to note that the word 'shambles' takes us back to the Norman market (although it's at the Saxon end), for it was they who used the word to describe such a place. The Saxons referred to butchers as Flesh Hewers – Fletchers and it is Fletcher Gate which appears as the name of the road alongside Weekday Cross, where the Saxon butchers did their business. Saxon and Norman butchers came together when they moved to the common market place. The earliest stalls on the shambles would have been temporary wooden structures packed away after each market. As times passed these would have become more elaborate and eventually permanent, as the shambles became a street of butcher's shops.

One of the first mentions of the market comes from the reign of Henry II (1154–1189). A charter signed by Henry tells us something of those who traded at the market when he decrees that, '... the men of Derbyshire and Nottinghamshire ought to go to the borough of Nottingham on Friday and Saturday with their wains and packhorses'. It has been suggested that this reference indicates that the market was held from sunset on a Friday to sunset of Saturday. The charter mentions the men of Derbyshire as well as Nottinghamshire and is indicative of the fact that at this date, the two counties shared a legal and administrative government under one shire-reeve (sheriff). They also shared a prison which was on the site of the old Shire Hall in High Pavement, now the Galleries of Justice Museum.

The diarist John Evelyn during his extensive tour of England visited Nottingham in 1654 and gives a good impression of the market at this time when he says: '... an ample Market Place with an open sough and pond in the centre, a mouldering stone wall down its midst, trees, saw-pits, stocks, pillory and ducking stool'. It seems that the market place was more than a place of trade.

Writing in 1931, J. Holland Walker elaborates further on Evelyn's description and it is worth quoting his words in full:

We know that the slope from Long Row to South Parade was broken by a bank and that the sandy soil near this bank was spoken of as "The Sands," and was used as a horse market for the soft soil would be excellent for trying horses. The horse pond which Evelyn mentions disappeared at an early date, but it would be very convenient for ducking scolds by means of a ducking stool if for nothing else. The sough or drain in front of the Long Row was not filled in until 1826 and the soil for filling this hole was fetched all the way from the top of Mansfield Road near St. Andrew's Church.

Between 1724 and 1726 the building known as the Exchange was erected at the eastern end of the market place, on the site now occupied by the Council House. This was the administrative heart of the market and replaced a shambles of buildings on the same site. At a cost of £2,400, (over £36,000 at today's prices), the building was designed by

Marmaduke Pennell. The Exchange was a four-storey building with an eleven-bay frontage 37 m long. It was considerably repaired and remodelled in 1815. By the mid-1870s the Council and Corporation of Nottingham had out-grown their accommodation in the Guildhall which stood where the Nottingham Contemporary now stands at Weekday Cross. It was agreed that rather than build a new building the Corporation should move into the Exchange. In 1877 the Corporation moved to temporary premises while the Exchange was converted to use for meetings. In 1879 the Corporation met in the Exchange for the first time thus making the site the ceremonial headquarters of Nottingham's civic government.

The old Exchange building was demolished in the late 1920s to make way for the current Council House. Designed as a multi-functional building, the Council House, on the ground floor, has at its heart a shopping arcade with access on three sides. Originally known as Exchange Arcade, now simply The Exchange, the arcade is still in use today. As the Council House building was opened on the 22 May 1929 by Edward Prince of Wales, later to become Edward VIII, the Exchange can therefore be counted as Nottingham's first 'modern shopping centre'.

In 1926 it was decided that the Corporation needed to be identified with a new purpose-built headquarters. To this effect, the old Exchange building was demolished and it was replaced by the modern Council House building we see today. The building was designed by Thomas Cecil Howitt and built between 1927 and 1929 in the neo-baroque style characterised by the huge pillars that encircle the building along with the carvings on the façade and the iconic 61 m domed tower which rises above the Old Market Square. The building was completed at the cost of £502,876. The bill was not finally settled until 1981 and with interest totalled £620,294. Nottingham's Council House was opened on the 22 May 1929 by Edward Prince of Wales, later to become Edward VIII.

Perhaps one of the few tributes to Robin Hood and his Merry Men is to be found in Nottingham is housed under the great dome of the Council House. Weighing over 10 tonnes, the hour bell of the clock is affectionately-nicknamed 'Little John' after the outlaw's faithful lieutenant. The bell has been many years the deepest toned clock bell in the UK with a chime that is reputed to be heard 7 miles away.

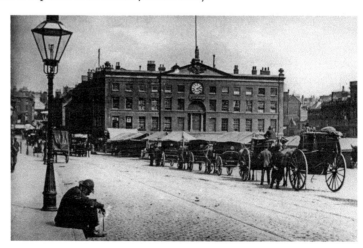

The Old Exchange taken from Long Row, c. 1896 (photograph credit: The Paul Nix Collection).

The impressive Nottingham Council House during St George's Day celebrations in 2012 (photograph credit: Joseph Earp).

To catch a glimpse of Robin himself it is necessary to enter the shopping arcade in the building and look up at the inside of the dome. Here, painted around the walls are painted murals with scenes from Nottingham's history including: the Danes capturing Nottingham in 868, William the Conqueror ordering the building of the castle in 1068, Robin Hood and his Merry Men and Charles I raising his standard at the start of the Civil War in 1642. The murals are the work of local artist Noel Denhol Davis (1876–1950). Davis used local celebrities of the time as models. Those identifiable are the architect of the building T. Cecil Howett (1889–1968) who appears in the guise of William the Conqueror's surveyor, and Notts County FC goalkeeper Albert Iremonger (1884–1958) as the mighty Little John.

Over the years, two stone lions have been proudly guarding the Council House. They have perhaps now become as iconic locally as Robin Hood or the Goose Fair. Just imagine the amount of people who have climbed all over them as children and later as adults and used them as a meeting point with friends and dates. There is a lot of local folklore connected to the lions. Perhaps the most famous is the tale of the lions 'roaring every time a virgin passes'. 'Meet you by the lions' is now a local saying in its own right. For some unknown reason over the years, the left lion has become the most famous of the two. However, a lot of people get confused as to which exactly is the left lion. Is it the one on your left as you stand on the Council House steps or the one on the left as you face them from the square? Let's tell you the secret, it is easy to locate him, just simply face the Council House from the square and the left lion is the one on your left!

Over the years the lions have become famous in local media and press. There is a local website named after the sculptures and of course the now famous local magazine called simply *Left Lion*. In 2006 Nottingham City Council used the lions on some of its promotional material, in campaigns and on stationery. There are alternative names for the lions, some people call them 'Menelaus and Agamemnon', others 'Leo and Oscar'. Those who meet by the left lion, particularly lovers and sweethearts all have their own secret name for him, one secret we can't reveal. Next time you are in Nottingham, let us know and 'We'll meet you by the Lions'!

'Meet you by the lions!' The left lion in the Market
Square, Nottingham, c. 1950s (photograph credit:
Nottingham City Council).

Broad Marsh

Work on building the Broadmarsh Shopping Centre (since 2013 now known as intu
Broadmarsh) began at the start of the 1970s. Controversially it was built on land in one of
the most historical areas of the city. Its rise saw the destruction of what is now considered
to be one of the best preserved medieval streets in the country. The centre opened in
1975 with fifty-five shops spread out over two floors with a total retail floor space of
45,000 m². The second of Nottingham's two bus stations lies on adjacent land on the
opposite side of Collins Street (A 6005). Constructed in the Brutality style of the period, it
is situated beneath the centre's multi-storey car park and is said to be the ugliest building
in Nottingham. The car park/bus station is connected to the centre by both a footbridge
and underpass.

Owned by Nottingham City Council and partnered by Intu PLC, plans to modernise and
upgrade the centre have been ongoing almost since the day it was opened. In 1988 some
cosmetic refurbishment was undertaken, but in the intervening years there has been two
major redevelopment plans approved but never executed. The proposal in 2002 was to
totally demolish and rebuild the centre, car park and bus station. The redevelopment
proposed in 2007 would have involved demolition of most of the centre, car park and bus
station and the creation of 400 shops spread across a massive retail floor space of 136,000
m², costing an estimated £400 million.

Even as we write intu Broadmarsh, part of which are still under wraps, awaits the
third redevelopment approved in June 2015, which when complete will see the creation
of a multiscreen cinema, restaurants, and a new, 'through' walkway which will link the
Midland Railway Station with the city centre.

Today's visitors to the intu Broadmarsh might be surprised to know that the ground
on which it stands, holds some surprising secrets, not least of these is the origin of its
name. That origin takes us back over 1,000 years to the time of the Norman Conquest

and the deliberate creation of a belt of marshland, a broad marsh and a narrow marsh. The name, originally Broad Marsh was, in the nineteenth century, once synonymous with deprivation and crime before its rows of terraced houses were demolished. A secret only discovered when the shopping centre was being built in the 1970s are some of the city's best preserved caves which lie beneath its busy shops. Here then, is the story of the original Broad Marsh.

When the Normans first built their castle on the summit of the mighty Castle Rock, they were not content to rely on this natural defence alone. To strengthen it further they diverted the course of the River Leen to flow below the Castle Rock, and from there it continued in an easterly direction, before turning it south to meet the River Trent. This diversion meant that it now flowed below the eastern end of the town on the sandstone ridge above. A road, called Leenside following the line of the river, link both ends of the foot of the ridge.

Because of the annual flooding of the Leen, the land on both sides, but particularly between the ridge and the river soon became marshy ground. Whether intentional or not the Normans had created a belt of marshland which stretched between the two prominences, Castle Rock and the Lace Market, at each end of the ridge. The western and wider area became known as the Broad Marsh, and the remaining (narrowest part), Narrow Marsh. In the fourteenth century the name Narrow Marsh appears under many spellings but documents of around 1315 calls the area 'Parvus Mariscus' – 'the little marsh'. A location suitable to get some idea as to the extent and appearance of Narrow Marsh is outside the BBC Nottingham building at the top of London Road. Looking north, one cannot fail to see St Mary's Church at the top of a 21 metre-high cliff. Here you are looking back in time to the city's origins and its oldest district. The marsh would have almost filled the ground between where you now stand and extended east as far as the NET (tram) viaduct. To the west, the Broad Marsh would have covered not only all of the ground upon which the shopping centre now stands, but would have extended further west to encompass all of the low ground below the Castle Rock.

Broadmarsh Shopping Centre, Lister Gate, Nottingham, 1982 (photograph credit: Nottingham City Council).

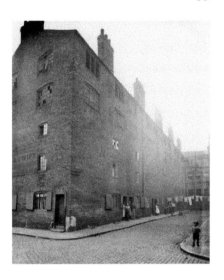

Grove Street, off Newcastle Street, Broad Marsh, 1934. These are just some of the many houses in the Broad Marsh area which were eventually pulled down to make way for the Broadmarsh Shopping Centre (photograph credit: Nottingham City Council).

At the end of the eighteenth century, authorities in Nottingham were looking to improve transport links for growing businesses in the town. In 1790 it was decided that a new canal was needed to link Nottingham into the ever-expanding network. To this end surveyor William Jessop was called in to determine a route. The Normans had done their work well and Jessop could find nothing that could beat the course of their engineered River Leen. Once again the river was diverted to make way for the building of the new Nottingham Canal.

The Nottingham Canal original proceeded from the Trent at Nottingham, via Wollaton and Cossall to Langley Mill, a distance of 14.75 miles, where it joins the Cromford Canal. The act to build the canal was obtained in 1792, and building work at the Nottingham end started almost immediately being completed by 1796. The entire length of the canal was completed and opened in 1802.

With the Industrial Revolution came the birth of the railway which more or less killed the canal as an economic transport route into Nottingham. Since the 1970s, the canal has enjoyed a rebirth as a nature reserve and walking/cycling trail. The stretch of the canal through the city has especially enjoyed the revival.

By the early nineteenth century, the section of canal in the city had become a mini port full of busy wharfs and well-stocked warehouses. With the decline of the canal many of the buildings went into disuse. Again, in the '70s, with the restoration of the canal for the use of leisure craft, the canal-side buildings were carefully restored into pubs, restaurants, cafés, gyms and luxury apartments. This fashionable area still retains the appearance of a canal dockyard and it is easy to imagine it in its busy heyday when viewing it from the road bridge on the London Road (A60).

One of the best preserved warehouses on the canal is that of Fellows, Morton & Clayton, the largest and best known canal transportation company in England. The building is now occupied by a trendy pub of the same name. One of the pleasures enjoyed by locals and visitors alike is to sit on the terrace outside the pub and soak up the atmosphere. But how many of those who do so know the story behind the tragedy that took place here in 1818? The secret is that this is not the original Fellows, Morton & Clayton building.

Explosion on the Trent

Hezekiah Riley was the captain of a boat that plied along the Trent up as far as Nottingham, where goods could be transhipped to and from the canals of central England. In September 1818 he took his boat, belonging to Richard Barrows, down the Trent to Gainsborough with its small crew of Joseph Musson and Benjamin Wheatley. He loaded up a mixed cargo of stone, cotton, molasses, soap and twenty-one barrels of gunpowder. The gunpowder, from the powder mill of Messrs Flower at Gainsborough, was destined for the mines of Derbyshire via Cromford, and each wooden barrel contained about 100 lbs of explosives. The boat was brought into the canal basin at Nottingham and moored under the arch of the warehouse for unloading into the dry of the stone building.

What followed was described at the time as 'a most dreadful calamity which threw the whole town into consternation and spread the most extensive devastation throughout the neighbourhood'. A man in the nearby Meadows area of Nottingham described how 'the whole warehouse appeared to lift up several yards into the air and then burst asunder into innumerable fragments'. The explosion was followed by a cloud of smoke which completely darkened the atmosphere.

Around a ton of powder had been unloaded onto the wharf and with the handling one of the barrels had spilt a little of its contents onto the floor. Thinking to play a prank, one of the two boatmen, Joseph Musson, dropped a hot coal into the pile expecting nothing more than a flash. The resulting explosion threw the joker 120 yards and although mortally wounded he survived long enough to admit his responsibility. The power of the blast destroyed the warehouse and caused damage in the streets between the canal and the Market Square.

The official report on the explosion gave the cause as being the 'poor quality storage of gunpowder'. The explosion was a devastating incident killing at least twenty men and boys. The estimated damage came to £30,000, which included 4,000 quarters of corn, some paper and cheese in the warehouse. The warehouse was insured, but the insurance company refused to pay up and the canal company sued Musson's employers, the Nottingham Boat

The Nottingham Canal, 2014 (photograph credit: Joseph Earp).

Company. They won £1,000 but the boat company could not pay, and had to settle for £500. The people of Nottingham set up a fund to help the relatives of the victims.

With the river gone and the marshes drained new land was now freed up for building. Very quickly, Nottingham gained two new districts taking their names from the two marshes upon which land they were built. The main thoroughfare through each of the districts were appropriately know as Broad Marsh and Narrow Marsh. By the start of the twentieth century, the two Marshes had become slums with a dense population living in streets of Victorian terrace houses. Narrow Marsh in particular had developed a notoriety as a place of poverty and crime. It has often been said that policemen when patrolling Narrow Marsh would only venture in pairs.

In 1905 attempts were made to improve the image of Narrow Marsh, one of which was to rename its main thoroughfare (Narrow Marsh) Red Lion Street after the eponymous public house. Writing in 1926, the historian J. Holland Walker has much to say about these 'improvements':

> One hardly recognises Narrow Marsh under its modern name of Red Lion Street which was bestowed upon it in an access of zeal in 1905. I think the authorities must have come to the conclusion that the cup of wickedness of Narrow Marsh was full, and that the very name had something unholy about it and so they thought that by changing the name they could change the character of the inhabitants.

Walker was right and the feigned effort at improvement was ineffectual on the natives. Despite displaying a board with painted red letters declaring it to be Red Lion Street the road, like the district continued to be known locally as Narrow Marsh. The chance for improvement came again in the 1930s when the Broad Marsh and Narrow Marsh districts were demolished, but redevelopment was piecemeal due to the intervention of the Second World War. The old Leenside road was renamed Canal Street. In contrast Broad Marsh should be considered as a holy place. Here is something you should think about if you should find yourself shopping in the Broadmarsh Centre. Wherever you walk, beneath your feet was once the consecrated ground of a Franciscan friary.

In the year 1224 the Franciscans – the last monastic order to come to this country from France – arrived in England. The Franciscans are among the few orders who, alongside their conventional brethren, have monks known as friars. Today we might consider friars as being a sort of outreach worker administering their faith among the local community rather than being confined to their priory. Franciscan friars were known as Grey Friars after the colour of the habit. Nottingham seems to have been one of the first places in England to have a Franciscan friary, which is mentioned in documents of 1230.

The friars came to Nottingham soon after their arrival in England and immediately appealed for land to build their home. They would have found that there was no open space large enough within the town walls to accommodate their needs and so they were given, possibly by Henry III, marginal land to the east of the town along the banks of the River Leen – Broad Marsh. Here they quickly established their friary, which naturally enough became known as Greyfriars Friary. Perhaps the first thing they did was to erect the massive stone Preaching Cross we know to have existed on the site. The precinct of the

friary extended between the Broadmarsh Road (now gone) to the north and Canal Street to the south, and included all of the land now occupied by the Broadmarsh Shopping Centre. The first buildings on the site were of wood. Records show that between 1230 and 1261, the king donated to the friars, vast amounts of oak timber, a valuable building resource, from the Royal Forest of Sherwood. In 1256, beginning with a new church, work started on rebuilding the friary in stone. Once again Henry fulfilled his religious obligation by granting the friars permission to use stone from his quarry in Nottingham. The church was not completed until 1303 the year in which it and the surrounding churchyard were consecrated. It took another seven years to complete the additional side-chapels which were consecrated in 1310. The new church would have served both the friars and the community (as a parish church) and while in use was considered one of the finest in Nottingham.

Greyfriars had its beginnings with the help of Henry III and it is somewhat ironic that it met its end 300 years later at the hands of another Henry, Henry VIII. Like every other monastic site in the country, it was dissolved as part of the Dissolution of the Monasteries. Greyfriars was surrendered to the authorities by its warden, Prior Thomas Basford, and seven other Friars on the 5 February 1539. It is interesting to note that the last warden was, judging by his name, a Nottingham man. Basford, once a rural village, is a suburb of the city.

We do not know what happened to the site in the nine years following the Dissolution, not until 1548. It was in this year that the friary and all its estates were granted to Thomas Heneage. By 1611 we find that the site had passed into the hands of Nottingham's Corporation. In that year the Corporation demolished the friary's boundary wall and removed the foundations of the Cross. Greyfriars disappears from the pages of history then only to appear briefly as a street name, Grey Friar Gate. But that too has now gone, swallowed up by the shopping centre along with the memories of the Franciscan Grey Friars who for 300 years made the Broad Marsh their home.

FRANCISCAN FRIAR.

An artist's sketch of what a Franciscan friar or Grey friar would have looked like. The Nottingham Franciscan house was one of the eight friaries in the wardenship of Oxford; it was situated in the south-west corner of Broadmarsh (photograph credit: The Paul Nix Collection).

6. Nottingham's 'Realm of Darkness'

We borrowed the title 'Realm of Darkness' for this chapter from the late Paul Nix, founder member of the original Nottingham Hidden History Team. Paul was a man of many talents and interests but one of his life's passions was the exploration of what he called his 'Realm of Darkness'. He was of course referring to the city's many caves and cave complexes, the very ones which supposedly gave Nottingham the name 'Tigguocabauc' – House of Caves. One of Paul's favourite sayings, a warning to visitors to the city was; 'Don't stamp your feet to hard, as you never quite know where you will end up!' This was of course his little joke, but the reality of the situation is that Nottingham is built above a veritable labyrinth of caves all of which are man-made. Here is a real secret about Nottingham; 'Outside Turkey, Nottingham is the largest urban conurbation in the world built over a network of entirely man made caves'.

A recent survey has shown that there are over 500 examples of rock-cut caves and cellars within the city limits. With an estimated 400 examples the area bounded by Parliament Street, Maid Marion Way, Canal Street, Bellar Gate and Cranbrook Street, has the highest concentration of separate caves (those not linked by tunnels or passage ways) in the city. It is possible that a further seventy-five have been lost or destroyed, while it is suspected that at least fifty or more await discovery. In the 1960s/1970s, Paul along with his fellow members of the Hidden History Team were among the first to explore many of these caves.

Nottingham is uniquely built on a high ridge of sandstone. Geologically speaking the ridge or escarpment, is made up of 230-million-year-old rocks of the 'old red sandstone' group. Once called 'Bunter Sandstone' the local formation is now referred to a Nottingham Castle

The late Mr Paul Nix from the Nottingham Hidden History Team under Long Row, Market Square, Nottingham, 1982 (photograph credit: *Nottingham Post*).

Rock sandstone after its most visually obvious example, the massive 40m-high Castle Rock outcrop, itself riddled with caves and passages. Under the city is a layer of sandstone around 60.92m thick which outcrops over an area of approximately 4km to 4.8km, broadening out as it goes north of the city. The three main cave complexes in Nottingham are: The Hermitage on Castle Boulevard, Sneinton Hermitage in Sneinton and Rock Cemetery.

There are two popular misconceptions about Nottingham's caves. The first is that 'they are like those in Derbyshire'. The second that 'they are damp, smelly and infested with creepy crawlies'. Dealing with the first point, it is fair to say that comparing the caves in Nottingham to those in Derbyshire is rather like comparing apples and pears. The Derbyshire caves are natural limestone caves, formed by the action of running water dissolving the rock, but the Nottingham caves are purely artificial. Nottingham's caves are not damp and certainly not particularly smelly. The granular porous nature of Castle Rock sandstone, acts somewhat like a sponge. Within the rock, water flows internally though its structure, passing down and around the walls of the cave, rather than dripping from the roof or running down the surface of the cave walls. The only place you may see dripping water is possibly, as Paul was fond of saying, 'where the hand of man has tried to improve on nature'. Where brick, metal, wood or some other material has been deliberately inserted into the rock, due to capillary action, water would divert from its natural downward course and cause it to flow over the surface of the inset material from where it could then drip. To test this yourself, if you lightly touch a cave wall it will feel dry and powdery, but if you press firmly and make good contact with the wall, you will soon find your hand getting damp. As for creepy crawlies they are conspicuous by their absence. They are not found in empty caves because they cannot survive on a diet of sand, it has zero calories, and the temperature, although constant, is below what they would find comfortable. There is however, a form of fungus which finds sandstone caves a most suitable place to inhabit. This fungi can be seen to form an ornate curtain of white lace like material and are always found to emanate from a piece of rotted wood.

The question arises as to how old are the Nottingham caves? The dating of natural caves, again like those of Derbyshire, lies with the remit of the geologists. For the historian or archaeologist, when dating the Nottingham caves, it is however a different matter. Literally as artificial holes in the ground or a cliff-face, the question is rather, 'when were they first excavated?' The simple answer is that no one really knows. Archaeological finds within a cave can only tell us when they were first and last occupied. Any dating arising from the analysis of 'tool marks' or architectural features does not take into account the fact that a particular cave might be the modification or extension of an early excavation. However, the historian can tell us when the Nottingham caves first entered the historical records.

The first historical reference to the Nottingham caves is Asser's Tigguocabauc of AD 885. A visitor in 1639 is recorded as describing Nottingham thus: 'A great many of the inhabitants, especially of the poorer sort, dwell in vaults, holes or caves which are digged out of the rock, so that anyone possessed of a mattock could easily provide himself with a house'. Neither of these references tells us for certain when the caves were first excavated.

The antiquarian Charles Deering in 1751 is more precise as to when the caves were first excavated. He attributes them to primitive Britons from a time before the Romans:

Nay it is highly probable, that as soon as these people were provided with tools for the purpose, finding in these parts a yielding rock, they might improve their habitations

by making their way into the main rock and framing to themselves convenient apartments in it.

It is to be remembered that Deering and his fellow antiquarians held a limited view of prehistory and classified any monument built before the Romans came to Britain, as Ancient British.

If we accept the three historical records as accurate there is one thing we can say for certain: there have been caves in the area where the City of Nottingham now stands for at least 1,200 years and for much of that time, they were being used as domestic dwellings. Unless we find clear datable evidence, when the first cave was excavated in Nottingham will remain a secret.

Trade, Industry and Commerce in the Nottingham Caves
In Nottingham the caves have had many uses for trade, industry and commerce. Edited and reproduced from an original composed by Paul Nix and the Nottingham Hidden History Team from their own fieldwork. As this is the first time that this material has been published, it can be counted as revealing secrets in the perfect sense of the word. It is accidental that the list begins with a cave connected with the Second World War and ends with one connected with the First World War.

Air-Raid Shelters
A cave complex at the top of Pelham Street still shows signs that it was used, during the Second World War, as an air-raid shelter. According to the Air Aid Shelter List for 1945 it was number 722 with accommodation for 100 people.

Bank Vault
Caves under Peck Lane, destroyed in 1975, were on the site of Nottingham's first ever bank owned by Thomas Smith (1631–1699), Mellors wrote of him:

Many of Nottingham's Caves were turned into air-raid shelters during the Second World War. The one in this photograph is in the City of Caves Museum in Broadmarsh and gives the visitor a good idea of what the shelters were like during the war (photograph credit: *Nottingham Post*).

He lived at the corner of Peck Lane. Being a trustworthy man, people from outlying districts, rather take their money through the dangerous county roads, left it in the care of Mr. T. Smith. For security of this money he had made under the kitchen basement of his shop three separate rooms cut out of the solid rock, approached by a trap door and ladder, and another set of rock rooms below these approached by steps partly under the public street.

Blacksmiths

A cave in Bridlesmith Gate, retains all the hallmarks of being used as a forge. It has a large central chimney which rises from the roof of the cave at 45 degrees, then narrows and rises vertically, thus stopping any rain from falling onto the fire. The inside of the chimney contained vast amounts of soot.

Brewery

One half of a cave complex in Goose Gate contained Nottingham's first brewery, Simpson's Brewery, built in 1792 on land leased from Sir Richard Arkwright. The site originally contained three or possibly four early cave malting complexes. These were knocked into one huge cave for barrel storage. This cave plus the slaughterhouse cave, to which it is connected, form the largest cave complex under the city.

Malt produced in Nottingham's caves was sold to local inns, most of which were brewed on the premises. While some, where space permitted, had brewhouses above ground, many like the Trip To Jerusalem, brewed in caves below their premises. It was once popular for visitors to Nottingham to visit these cave breweries to sample their product. In 1679 one such visitor was Miss Celia Fiennes: 'Att ye Crown Inn is a cellar of

Caves under Goose Gate, c. 1980s (photograph credit: The Paul Nix Collection).

60 steps down, all in ye rock like arch worke over your head; I drank good ale.' The Crown Inn no longer exists and its whereabouts is unrecorded. During clean-up operations by Paul and the Hidden History Team in the caves at the Salutation Inn on Hounds Gate, they found evidence that 'good ale' had been brewed here for many years.

Butchers

One half of a cave complex in Goose Gate was an underground slaughterhouse although it is not large enough to have coped with cattle and may have only been intended for sheep, calves or pigs. In it there are butchering thralls to cut the carcasses up on, with drains and spaces to put a bucket to catch the blood. A thrall found topped with sand turned out to be a salting trough used to treat meat to make it keep, they did not have refrigerators in those days. Investigation into the properties owners showed that over many years they had been pork butchers.

Paul Nix, report for Nottingham Hidden History Team.

Candle-making

Candle-making was a trade that required a continuous fire to keep the tallow molten. It is known that the trade in Nottingham would have been relegated to a cave due to by-laws appertaining to curfew. A curfew was a metal device for covering a fire at night, the term originates from an order of William the Conqueror who worried about his subjects plotting against him at night, so he directed that at the ringing of the bell at eight o'clock everyone should rake up their fires and retire to bed.

Catacombs

In the early 1900s, planned catacombs were partially completed in the Rock Cemetery on the Mansfield Road (A60), at its junction with Forest Road East and Mapperley Road. Work stopped when the project ran out of money and they were never finished or occupied.

The Caves in Rock Cemetery were originally built as catacombs (photograph credit: Joseph Earp).

Chapel

The Hermitage or Papist Holes are perhaps one of the best known cave complexes in Nottingham. The caves were once a rock-hewn monastic church or chapel dating from at least the twelfth century known as St Mary Le Roche. St Mary's was founded as a satellite chapel to Lenton Priory, a chantry where the monks said prayers for the soul of the king. Within the church and other caves are: aisles, pillars, an altar, kitchens, a refectory, a dovecote, a dormitory and possibly a steeple for a bell. Evidence shows that there may once have been wall paintings. In 1475, St Mary's and its lands were given by the priory to the king and Gervase Clifton in exchange for the chapel in Tickhill Castle on the condition that the priory continued to supply monks to say mass. Services at the church ceased around 1500 and it rapidly fell into decay. During the Civil War Puritan forces destroyed a great part of the Hermitage, declaring the caves to be Papist Holes. Paul comments on the Hermitage, 'It is quite obvious that when the chapel was constructed they extended and modified some existing caves that may have been there for many years'. The site is now behind modern apartment buildings on Castle Boulevard.

Charnel Pit

A cave system in Bridlesmith Gate has been found to contain three charnel pits, one of which had vast amounts of medieval pottery in it.

Chemist

Another cave in Bridlesmith Gate contained a rock-cut work bench that had been used by Mr Cox, a chemist, to produce his patented Black Oils. There were also niches for urn-type jars containing chemicals.

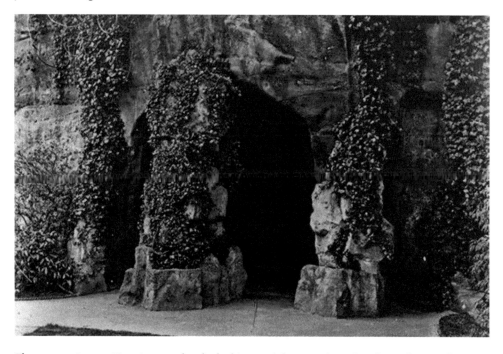

The caves at Lenton Hermitage as they looked in 1910 (photograph credit: The Paul Nix Collection).

Coach House

In the Park Estate to the west of the castle, there are a number of coach houses cut into the cliff face which backs onto the castle grounds. These were created for the benefit of the owners of the grand houses of the estate.

Conduits

In the 1850s a conduit was constructed through the bedrock, by the Nottingham Waterworks Company along the length of Castle Boulevard. The conduit supplied water to their new waterworks at the end of Castle Road.

Cutlery

Caves beneath a building that once belonged to a cutler in St Peters Gate contained many used and worn-out sandstone grinding wheels of the kind used to finish and sharpen the old cast-iron cutlery.

Dungeons

Rock-cut cells are still evident beneath the castle and the old Shire Hall on High Pavement.

Fish Gutting

In one of caves to the rear of Fisher Gate the Hidden History Team, not unexpectedly, found a fish-gutting trough.

Fish Tank

A cave in the Hermitage complex contains a fish tank. The tank would have been for fish caught in the River Leen, it flowed past this site. Fish were a vital and staple part of the diet of a medieval monk.

Foundry

In the block of land between the Council House and Parliament Street was for many years a large foundry that produced cast-iron ranges etc. Caves beneath the building were used in the manufacturing process.

Garderobe

A cave beneath buildings on Castle Gate, part of a complex used as Maltings, has one of the finest examples of a garderobe (medieval toilet) found in any of the Nottingham caves. It measures 2 metres wide, 5 metres broad and 3 metres deep.

Guard Room

Examples of medieval guard rooms are to be found under the castle set within Mortimer's Hole and the Western Passage.

Greenhouse

A garden of a terrace house in the Ropewalk is a cave known as The Greenhouse. The name comes from a nearby school which used it as a sort of horticultural classroom, 'terming it their greenhouse'.

Entrance passageway to the caves known as
the Greenhouse located in the Ropewalk, 1984
(photograph credit: The Paul Nix Collection).

A buttressed brick entrance in the cliff face leads into a passageway that runs for
some twelve feet (3.5m). At this point the passageway splits and goes off to the left.
The junction in the passageway opens out into a small area where four steps go up to
a bricked-up doorway. Looking down the chamber it has a trough running around its
outer perimeter and at the far end we see a window which looks out into the gardens.
The trough was partially filled with soil but at one end, there was a small fireplace built.
A little investigation showed that from the fireplace a tunnel ran inside the trough, so
that hot air produced by the fireplace would circulate underneath the earth – was this a
Victorian cave seed-propagator? It was well-lit from the window which appeared to have
contained coloured glass at one time.

<div style="text-align: right">Paul Nix, Field Report.</div>

House

Although there were many caves in Nottingham used or created as domestic dwellings,
few examples have survived. We must not think of these as being simply primitive open
cave mouths leading into a rough irregular chamber. As old photos and documents
show, they had a high degree of sophistication, often with brick frontage complete with
windows and doors. Entering through the door we would have found all the appearance
of any brick-built home. With the Enclosure Act of 1845, it became illegal for people to
live in caves within Nottingham. Cave houses were abandoned and the vacated caves
were soon converted to other use, which resulted in the destruction of any signs of their
former domesticity.

Leper Colony

Caves to one side and the rear of a public house on Sherwood Street once housed a leper colony, a window (hole in the rock) facing onto the road is said to have been where people would have left food for the poor victims of this affliction.

Malting

A cave discovered in Castle Gate contains the best preserved example of a cave malting complex.

> A central flight of steps leads down to a large rectangular chamber with a central pillar. A small landing two thirds of the way down on one side has a well and a small cave opposite. On the other side of the landing is the upper entrance to the malt kiln. From the large chamber at the bottom there is a second opening into the malt kiln, this is the fire pit. The malting process in caves, started first by spreading malt thickly in the small cave, then water from the well was poured over the grain to steep it. When the grain had swollen and burst open it was quickly transferred over to the malt kiln. Here, it was spread in a thin layer on a net stretched over a charcoal fire in the bottom of the kiln, to kill the grain and stop it germination. This process used most of the cave's inherent features, namely constant temperature, a total lack of daylight to stop the grain's germination and pure water to steep the grain in.
>
> Paul Nix, Field Report

In the reign of Charles I it was said that 'in the subterraneous malt rooms' of Nottingham, they used to make 'malt as kindly in the heat of summer as above ground in the best time of the winter'.

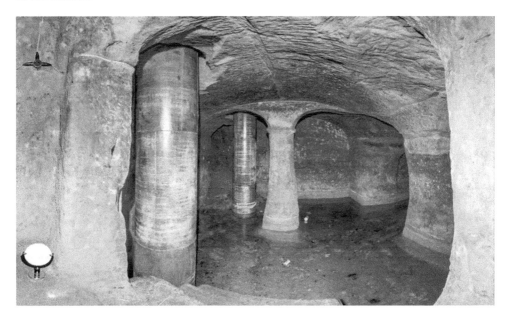

Caves under Castle Gate which were used for malting (photograph credit: Trent & Peak Archaeology/ The University of Nottingham).

Nut Store

When demolition of building's on Tree Lane was underway, a cave was uncovered which was found to be full to the brim with walnuts.

Post Office

The outer brick façade of the Post Office, which once stood at the bottom of Hollowstone, hid the fact that the rest of the accommodation is made up of caves (rooms) cut into the cliff face at the side of the road.

Prison

Under the site of the old Central Market 10 metres down are the remains of the lower passageways and cells of the House Of Correction that stood on this site.

Pub Cellar

Virtually every public house in Nottingham had a rock-cut cellar beneath it (as do many private houses and commercial premises). The best preserved are those of The Salutation, Ye Olde Trip To Jerusalem and The Bell Inn.

Replica of a Temple

In a cliff face, on a garden terrace a house on the Ropewalk, is a cave called the Colonnade.

The Colonnade is a rectangular chamber 5m (16.4ft) wide at the cliff face and going into the cliff for 9m (29.5ft). Inside the chamber there are three parallel rows of six pillars, each of these are all free standing, connected only to the floor and ceiling. The height of the ceiling is 2.5m (8.2ft) and is mostly level. All the pillars measure approximately 35cms (13.7ins.) across, but some are worn and one has had bricks put around it. The entrance to the cave is through a very large doorway with another pillar in the centre of it. From this entrance to the back of the cave the floor is covered in bricks laid flat and at the far end a series of steps leads us up to the bricked-up passageway entrance mentioned earlier. Looking down the left-hand wall of the cave there are six niches, each niche having a carved statue. Most of these are very worn, partially due to the nature of the rock, from which they are cut. Bunter sandstone carvings do not fare well in exposed or draughty positions, also these carvings have had many hands on them over the years. At least two of the statues are quite unrecognisable. The niche nearest to the entrance is an old bricked-up doorway. The right- hand wall of the cave has seven niches, all were plain except the third niche from the entrance end. In this niche, which has a rounded top, there is a crucifix and below this some writing has been scratched into the rock, but it could not be decipher ed. The floor of the cave is rock. To the rear of the cave, either side of the steps mentioned earlier, are yet two more doorways, these were also bricked up. The eighteen pillars in the cave each have a thick base which can be up to 51cms (20ins.) across but 46cms (18in.) from the floor, they taper to about 35.5cms (13.9ins.) wide. The pillars stay at this width to within 30cms (11.8ins) of the roof where they again splay out. Most of the pillars exhibited a wasting effect about shoulder height, possibly due to people catching them as they pass by.

Paul Nix, Field Report.

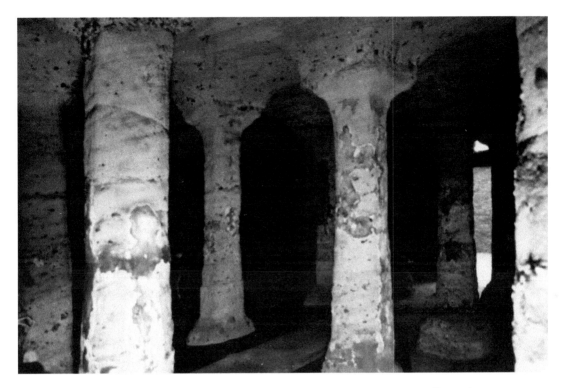

The Colonnade caves in the Ropewalk, 1984 (photograph credit: The Paul Nix Collection).

Sand Mines

There are several examples of supposed sand mines among the Nottingham caves. Perhaps the best documented is that of a Mr Rouse. This mine ran under part of Sherwood Street from an entrance on Peel Street. The mine was forced to close after a partial collapse killed a number of the workforce by burying them alive in sand and rock. The abandoned mine became an attraction during the reign of Queen Victoria, when at the time of the Goose Fair it was lit by gas lamps and opened to the public.

Stable

A part of Castle Rock adjacent to Brewhouse Yard is known affectionately as Elephant Rock. Caves within the base of this where once used as stables.

Store Room

Paul comments: 'Too many to mention, almost everybody had one'.

Summerhouse/Grotto

The Summer House or Grotto was one of the garden features built in 1856 by Alderman Thomas Herbert. Yet again it was one of the many caves explored and recorded by Paul and the Hidden History Team. In his notes Paul mentions the discovery of a previously unrecorded inscription: 'Examination of this summer house, or bower, located a date of 1872 incised into the wall...'

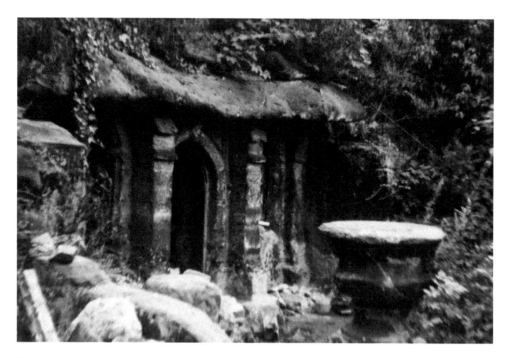

Entrance to the Summer House or Grotto Caves in the Ropewalk, 1984 (photograph credit: The Paul Nix Collection).

Tanning

A tannery forms the largest part of the cave complex below Broadmarsh Shopping Centre. Originally the caves would have been at the bottom of the slope of Drury Hill. Records show that in 1667 there were 'forty seven tanners yards in that place' and that visitors to the town were frequently 'saluted with a volley of suffocating smoke from the burning of tanner's knobs and gorse'. The underground tannery has all of the features of its neighbours on the surface, including tanning and hide de-hairing pits.

7. The Tourist Trail and Recommended Places to Visit

We thought that for the last chapter, we would take the reader through Nottingham on a trail of places to visit and things to see. Along the way we will look again at some of the places already mentioned elsewhere in this book and at the history of each specific area through which we pass. We will, where appropriate, introduce new sights (and sites) and will explain what can be seen today. All of the routes are accessible by foot, although some readers might like to follow them on a street map. The route starts at Trent Bridge and covers most of the important areas to see.

The Ancient North–South Road

Nottingham Trent Bridge to Rock Cemetery: total distance by road around 2.5 miles.

The reader will not be surprised to know that the first journey we will be making is one from the south, following as near as modern roads will allow, the ancient thoroughfare that has been a constant theme to this book. Let us begin where the ancient highway met and crossed the equally famous north–south divide at the Trent Bridge. Because of the total distances involved and modern road layouts we have split this trail into three parts.

Trent Bridge Inn to Cattle Market Road – Distance around 800 m.
Start Point: The Trent Bridge Inn, West Bridgford, Nottingham, (NG2 6AA).

The Trent Bridge Inn: This inn was owned by widow Mary Chapman who married cricket-mad landlord of The Bell Inn, William Clarke, in 1838. One of the things that attracted William to Mary, was the 'quaint little meadow' to the rear of the inn. No, it wasn't a conversion to a beer garden the landlord had in mind, it was a cricket pitch.

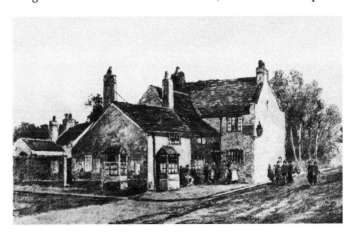

The Trent Bridge Inn, 1885 (photograph credit: The Paul Nix Collection).

And what a cricket pitch it was to become. In front of you is not only the inn but also Nottinghamshire County Cricket Club, one of the world's finest cricketing venues.

Island's Secret: Now turn your back on the doors of the inn and look across the busy A60 London Road. Between the A60 and a short slip-road taking one line of traffic onto Trent Bridge is a triangular traffic island. Although partially covered with trees and surrounded by a low stone wall, at ground level the island appears unremarkable. However, when viewed from above, the island reveals its secret. Set in a purpose-built hole in the ground are two stone arches of the medieval Trent Bridge.

Trent Bridge: The first bridge is likely to have been built of wood and was known as Hethbeth Bridge. At the time, this bridge was considered to be the most important in England and is the only one of its kind to be mentioned in the *Saxon Chronicles*. In 1156, during the reign of Henry II, the old wooden bridge was replaced by a more fortified stone structure with over twenty arches (two of which can be seen in the modern traffic island). In keeping with medieval practise of the time, the bridge had its own chapel dedicated to St James, either built upon it or by its side at one end. Only six such bridge chapels survive in England today.

Tarbotton's Bridge: Being ever mindful of the road traffic on the busy A60, we may take a short walk north onto the Trent Bridge of today. We are now standing on the third bridge, (Nottingham's Trent Bridge), to cross the river hereabouts. Built between 1924 and 1926 the bridge was designed by Borough Engineer Marriott Ogle Tarbotton and was opened to traffic in 1871.

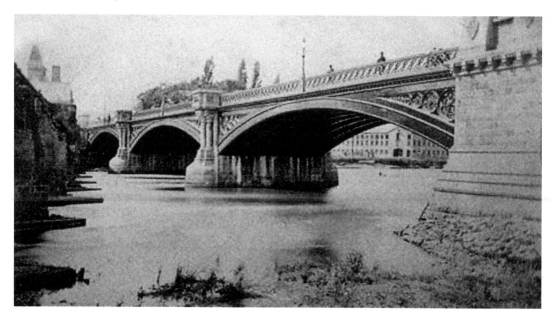

The old and new Trent Bridge, 1870. After the new Trent Bridge was opened in 1869 the old bridge was retained for a time. The photograph shows how the new bridge met the old one in the north near the Town Arms (photograph credit: The Paul Nix Collection).

Looking from the eastern side (right-hand carriageway), we get a fine views of the Trent End Stand of Nottingham Forest FC's City Ground Stadium on the south bank of the river, and Notts County FC's Meadow Lane Stadium on north bank. The secret here is that the city ground is actually in the county and Meadow Lane in the city.

Trent Embankment: Seen from the opposite side of the bridge, on the north bank is Victoria Embankment Park and Gardens. Space does not permit us to justice to this rather charming Victorian masterpiece, a combination of riverside walk, parks and gardens and Nottingham's principle war memorial. We suggest that anyone following this trail spend time exploring its secrets for themselves. However, there is one secret we couldn't resist telling you: the statue of Queen Victoria, unveiled in 1905, which once stood on the western side of the Old Market Square, was banished to the Memorial Gardens in 1953, but perhaps that is where she always wanted to be. There is a legend that tells how on certain nights as Little John, the bell of the Council House clock strikes midnight, she would climb down from her plinth and make her way to Trent Bridge. However, she was always certain to be back on her plinth before dawn.

Nottingham Canal and Cattle Market: return now to the eastern side of the road and continue over the bridge. We are now heading towards the city along the A60 London Road on the eastern edge of The Meadows. To our right and running parallel to the road is the Nottingham Canal. The canal is accessible from the road and for those with both the time and the energy is well worth the effort of walking its tow-path into the city. A pleasant walk of around 9 miles will bring you into the canal basin where the tragic explosion of 1818 took place.

The Queen Victoria statue, 2014. The statue originally stood in Old Market Square on Beast Market Hill and was moved to the memorial gardens in 1953 (photograph credit: Joseph Earp).

Journeys End: Our journey must end a few hundred metres down the road at the point where an iron bridge spans the canal to the gates of the city's Cattle Market. A view from this side of the canal gives a good impression of the buildings of this once thriving market. Although no longer trading in livestock it still houses a number of businesses and auction houses.

Weekday Cross (NG1 2GB) to The Adams Building (NG1 1PR) – distance around 0.2 miles.
Start Point: The Weekday Cross NET Tram stop.

Weekday Cross: We now follow the ancient route along Weekday Cross into the area of the original Saxon market place. The first mention of the market cross, which gave the road its name, comes in the mid-1500s. The old cross was pulled down in 1804 due to it being unsafe. The present cross we see today is quite modern, having been erected in 1993 by the Nottingham Civic Society. It is hard to imagine now, that the cross once stood at the heart of a busy market surrounded by the political and legal buildings which made Nottingham a town. Here for many centuries was the site of the town hall, the guildhall and the town prison. Leaving Weekday Cross, we turn down on to High Pavement, but before we do so it is worth lingering a while to take a look at Nottingham Contemporary which stands at the junction of the two roads. This modern building stands on the site of the old town hall and houses an art centre and café for a refreshing cuppa or more. Here too we can observe the line of the Great Central Railway which once ran in a cutting parallel to Weekday Cross.

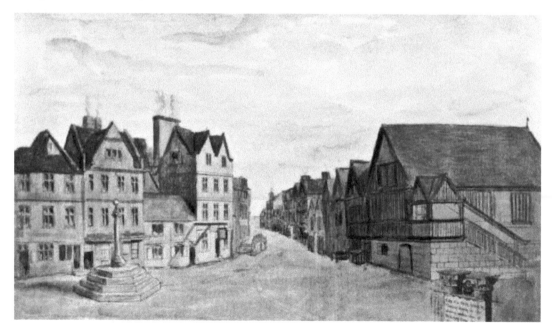

Weekday Cross looking east, as it originally looked prior to 1804 (photograph credit: The Paul Nix Collection).

High Pavement: From Weekday Cross we come down High Pavement. This street is one of the oldest thoroughfares in the city and most of the buildings along its length are listed. Here you will find one of Nottingham's premier tourist attractions, The Galleries of Justice Museum. The building which houses the museum was originally known as the Shire Hall. Buildings on this site have been used first by the Normans. The Shire Hall was the place where sheriffs were appointed to keep the peace and collect taxes, a courtroom, gaol, place of execution and a police station. The first written account of it being used as a law court go back to 1375 and the first reference for it being used as a gaol date back to 1449. The current building is reputed to be the most haunted in Nottinghamshire. The modern museum was set up in 1995 and since, has become one of the finest prison museums in the country. Buying a joint ticket at the museum will also get you admittance to another of Nottingham's top attraction, The City of Caves located in the intu Broadmarsh Centre. Before leaving the galleries take a careful look at the outside of the building, there are two secrets in stone to find, one an amusing spelling mistake and the other, a grisly reminder of the building status as a place of execution. We'll give you an idea of what they are, see if you can find them. Above one of the two basement windows the mason who laid the stones has carved the word goal instead of gaol. Instead of replacing it with a new stone, bearing the correct spelling, they have tried to re-carve the middle letters over the first inscription.

Take a look at the steps outside the front door of the building. If you look closely, you will find a number of square holes, approximately 10.16 cm^2 cut into the steps. Each of these has been carefully filled with a block of new stone. The steps were once the site of the temporary gallows where felons were publicly executed. The holes are the sockets for the upright post of the wooden scaffolding supporting the gallows.

The mason's spelling mistake can be seen on the basement window to the Shire Hall (photograph credit: Joseph Earp).

Hollowstone: At the opposite end of High Pavement to Weekday Cross, the road (and our route) joins Hollowstone the true ancient highway from the south. Here, we are literally walking a thoroughfare that was already ancient when Snott first built his settlement. Without a doubt, Hollowstone was one of the main routes into and through the Saxon Snottingaham. As a continuation of Bellargate/London Road it climbs the sandstone ridge from the Narrow Marsh at the foot of St Mary's Cliff thus avoiding the cliff and steepest incline. It is probably the route taken by the ancient highway we are following. We however pick up its route at the point where it is joined by High Pavement and Stoney Street.

St Mary's Church: The junction of High Pavement, Hollowstone and Stoney Street is dominated by Nottingham's oldest Christian church. First mentioned in the Domesday Book of 1068, St Mary's is believed to have been built when or just after the pagan Anglo-Saxon inhabitants of Snottingaham converted to Christianity. The Domesday entry, one of twelve for Snottingaham, indicates that it was a royal church – 'within the King's lordship' – and is described as having about 75 acres of land and extensive property giving a good income. Its priest is named as a man called Aitard who has 'a croft of 65 houses'. The building we see today is around 500 years and is the third church on this site.

There are those who would have us believe that the Christian Anglo-Saxons deliberately built their church on or close to the site of an ancient pagan idol – the Hollow Stone. A visit to the church is recommended, as there is much of interest about this ancient edifice. The church is open most weekdays and weekends, but we suggest checking their website for opening times.

Stoney Street: We are only briefly on Hollowstone, for at the point where it is joined by High Pavement it becomes Stoney Street. Another of Nottingham's ancient thoroughfares, Stoney Street runs like an arrow for around 320 m, through the heart of Nottingham's Lace Market District. Broad Street, a continuation of Stoney Street, continues in the same straight line for around the same distance. And so they might for there is some evidence that suggests the combined roads were of Roman origin. Although there is

Hollowstone, Lace Market, 2014 (photograph credit: Joseph Earp).

no archaeological evidence for any Roman activity in the area the first use of the name Stone(y) Street suggests otherwise. During the reign of King John, Broad Street is referred to as 'Stane (Stone) Street of Nottingham'. The word 'street', from the Latin *strata*, was first used to indicate a Roman road. At a time when few roads were nothing more than primitive tracks, surviving Roman roads with their paved surfaces were at a premium. Stoney Street is one of only two true early streets in Nottingham all the other roads are given the name Viking name 'gate' or Norman 'lane'.

Lace Market: The Lace Market, now promoted as Nottingham's Cultural Quarter was once the commercial centre of Nottingham's world famous lace manufacturing industry. Walking along Stoney Street we are surrounded by the tall, multi-storey factories and offices of all of the top lace makers of the nineteenth century. Perhaps the best example to be found on Stoney Street and in the whole area for that matter, is the Adams Building. Built as a lace showroom and warehouse for lace maker Thomas Adams has been described as 'the largest and finest example of a Victorian lace warehouse to survive in the Country'. Designed for Adams by the Nottingham architect Thomas Chambers Hine, the Grade II building now forms part of the city campus of New College Nottingham and operates a popular Adams Restaurant.

We end this part of the journey here and pick it up again on the A60 Mansfield Road by the entrance to the intu Victoria Centre. For those wishing to continue the journey on foot it is simply a matter of walking down Broad Street. At its junction with Low Pavement turn left and continue to the Milton Street–Low Pavement junction and the main entrance to Victoria Centre. A total distance of around 0.5 miles.

Stoney Street, Lace Market, Nottingham, *c.* 1914. Looking south from Carlton Street, showing lace workers coming home from work. The photograph was taken just prior to the outbreak of the First World War (photograph credit: Nottingham City Council).

Thomas Adam's lace warehouse on Stoney Street, now known as the Adams Building (photograph credit: The Paul Nix Collection).

Intu Victoria Centre (Milton Street Entrance) to Rock Cemetery – distance around 1.12 km (0.7 miles).
Start Point: Intu Victoria Centre (Milton Street Entrance).

We have now arrived at what should by now, be a familiar spot to the reader and there is no need for any further description. This third and last part of this trail will take us along the A60 Milton Street/Mansfield Road (for the purpose of this book we will refer to the whole route as the Mansfield Road). This is of course the old road to the Nottinghamshire town of Mansfield through what was once the heart of Sherwood Forest. At the Mansfield end the road once ran past a cliff of castle sandstone full of an entire village of the same cave houses as found in Nottingham. However, before we delve too deeply into the secrets of the old Mansfield Road we will start by saying something about the road as it is today.

Mansfield Road today: Mansfield Road has always been the main road out of Nottingham to the north a fact that as it is now the A60, is still true today. This in mind, the section of road now within the city has become a very busy shopping thoroughfare. For just over half of the distance to our destination, Rock Cemetery, the left-hand side of the road is lined with the buildings of the shopping centre. Standing on the site of the Victoria Railway Station these buildings give us some idea of the true scale of the Mansfield Road frontage of the station. About halfway along this row of buildings we come to the only remaining reminder of the sites former occupier, the Victoria Hotel and the Station Clock Tower.

Antique Bookshops: The opposite side of the road to the centre is lined with a good variety of shops, pubs, café and restaurants. We would like to draw the reader's attention to a particular shop – which, in a way contributed to this book. Mansfield Road was once renowned for the number of antique and specialist bookshops only one of which now remains. Jermy & Westerman established in 1978, is now owned by father and son Geoff and Richard Blore. The shop covers two floors and has a collection covering all subjects from popular reading to rare and interesting books, magazines and comics.

Old Mansfield Road: As we have already noted many times this was the way to the north from Nottingham, but more specifically, in the eighteenth and early nineteenth centuries

Jermy & Westerman's Antiquarian Bookshop on Mansfield Road is Nottingham's oldest book shop and has been owned by Geoff Blore since 1978 (photograph credit: Geoff Blore).

it was the route taken by the daily mail coaches from London, via Nottingham, bound for Leeds and York.

Not many people know that almost the instant the old Mansfield Road exited the town's north gate (around our starting point) it entered Sherwood Forest. Not only was the medieval traveller out of the rule of the towns authority, but they were now in the jurisdiction of the sometimes harsh Forest Law. The importance of the road is confirmed by records in the Domesday Book of 1068. Here it is referred to as, 'the road towards York' and is declared as being a King's Highway. Such roads were governed by royal decree, with their own laws, one of which forbade 'ploughing or the making of a ditch within two perches of the road', 10m, on pain of a fine of £8 (around £5,000 in today's money).

The compliance of this law meant that all of the early settlements within the forest, like Arnold, were built well back from the road with their own connecting tracks. This made it a lonely and dangerous road to travel for the individual. However, there was some comfort along the route in the form of 'The Hutt' – opposite Newstead Abbey gates – a landmark still familiar to today's traveller.

The Hutt was built sometime in the twelfth century as a garrison for men-at-arms to guard the highway through the forest. It was one of seven such huts built in the seven royal forests. It became a gathering point for solitary travellers to wait until there were sufficient numbers, before continuing their journey together through the notorious and aptly named Thieves Wood.

Before the advent of the turnpike road in the eighteenth century, the Mansfield Road remained a sandy ill-defined track, deeply rutted with the passage of carts and waggons pulled by teams of oxen or horses. Maintenance of the road was patchy and carried out at the expense of the local landowners. However the section of the road we are walking may well have been better maintained by the town's authorities or leading citizens. From Nottingham, the road followed much of the route it does today, except in the district of Ravenshead, where until 1785, it passed via Papplewick, through the grounds of Newstead Abbey rejoining the modern road just past Larch Farm.

View as seen from the top of the Mansfield Road looking into Nottingham, in around the early 1800s (photograph credit: The Paul Nix Collection).

A document relating to a 'Perambulation of Sherwood Forest' made in 1218 by the Knights and Free Tenants of Nottingham, provides a good description of the route. The precession is recorded as starting on Trent Bridge and proceeding through the town via Stanstrate – Stoney Street. Exiting through the north gate of the town walls, it climbed Gallows Hill to the village of Whiston – close to the junction of Mansfield Road and Mapperley Road.

Gallows Hill: For those who have been following this trail on the ground as it were, it will be noticed that from leaving our start point the road has slowly become steeper, more so after the northern end of Victoria Centre is reached. This is because the road is climbing a hill once known as Gallows Hill from the very fact that the town gallows once stood on its summit. Before the Turnpike Act in 1750 the road into a turnpike, a toll road governed and maintained by a trust, the summit was much higher making the gradient of the slopes on both sides much steeper. With adequate funding provided by the trust the summit of the hill was reduced and the gradients lessened.

At the top of the modern summit is the cross road junction of Mansfield Road and Mapperley Road. In the north-west corner of the junction are the iron gates of Rock Cemetery (more on this site later). It is likely that this was the site of public execution by hanging and here stood the gallows, the instrument of that execution. The gallows, resembles a stouter version of a football goal posts with the crossbar about 3.5 m height was on permanent display in this prominent position as a warning to those both leaving and approaching the town.

The method of execution was to tie a noosed rope from the crossbar, a ladder was placed against the gallows by the side of the rope. The victim was forced to climb the ladder and either from behind the victim or from a ladder by the side, the hangman placed the noose around the neck of the victim. When all was ready, the ladder under the victim was removed leaving the victim hanging. Another popular method was for the rope to be placed around the victim's neck while they were standing on an open-backed cart or waggon. Once again, when all was ready the means of support, the cart, was moved away leaving the victim hanging. Whatever the method it usually resulted in a death

Mansfield Road, 2012. This spot between St Andrew's Church and the Church (Rock) Cemetery was approximately the site of the gallows and locally known as Gallows Hill (photograph credit: Joseph Earp).

by slow strangulation for the victim rather than a broken neck, the result of hanged on a trapdoor gallows. Such was the suffering of many victims it was often the case for a friend or relative to pull on the legs of the victim to hasten death (hence the expression to pull someone's leg).

The gallows were removed after the place of public execution in Nottingham was removed to the Shire Hall following the execution on 2 April 1827, of William Wells, condemned for 'Highway Robbery'. It is interesting to note that the route taken from the old Town Hall to Gallows Hill by the condemned was via Weekday Cross by way of Bridlesmith Gate, High Street, Clumber Street, Milton Street and Mansfield Road.

Whiston: The village of Whiston mentioned in the 1218 'Perambulation' document is something of an enigma. The meaning of the name in modern English is not at first obvious. It is in fact two Anglo-Saxon words; hwit (white), stan (stone) – Whitestone. The village is said to have grown up around an actual white stone. The term whitestone was often used to describe a mark stone, a boundary stone or one marking a meeting place or important site. It was not unusual to give such stone a coat of limewash to make them stand out in the landscape. In the Forest Stone (formally White Stone), Nottinghamshire two forest courts met, one every three years and the other every seven years, to administer forest law.

However, it is not the name of the village that is the enigma, there are other places in England called Whiston. The mystery is that the village should not exist, at least not on the site it supposedly stood. So, where was Whiston? Well, we passed the site on the way to the top of Gallows Hill. The site, from both and historical references and archaeological evidence was somewhere between Huntingdon Street (A60) and York Street, which puts it right under the Victoria Bus Station. Given the date of the earliest reference c. 1217/1218, there are two reasons why there should not be a village or settlement of any kind on this site. The first is such a settlement brakes the law on the 'King's Highway', the site is too close to the road. The second is that it is too close to the town walls of Nottingham. There are no other examples of a medieval village so close to a town of the same age. One theory is that it is an old suburb of the town which was not included when the wall was built. But

this was no shanty town but the theory falls down when we learn from later references that the village had its own church, St Michael's, which survived until 1328. A story tells that the church was regularly frequented by drunken soldiers causing trouble and was demolished after a priest was killed.

There is a second theory which states that Whiston was a village created for either royal foresters or as a garrison for soldiers. Both of these hold water when we put together the facts that we already know. The village could have only have been created by royal authority and it stood within Sherwood Forest. Add in to this mix the facts that there was another 'white stone' in the forest connected with royal authority and forest law, the Hutt, a royal garrison with soldiers to protect the Kings Highway. Putting all these together, things start to make more sense. We cannot say for certain but Whiston is likely to have been and or both a Foresters village for soldiers and their family, who on royal authority, protected the Kings Highway.

It is also possible that the white stone itself was one of the 'great guide stones' that at intervals marked the route through the forest. There are two other possible examples on the road between Nottingham and Mansfield. The first, known as the Robin Hood Stone, stood by the side of the road close to the Hutt. The second, known as the John Martyn Stone, stood in the middle of the road on the outskirts of Mansfield. Whatever the true story of Whiston, the village disappeared c. 1514/1515 when the area was granted to Hugh de Bell to cultivate land there.

Church (Rock) Cemetery: We are standing outside the gates of Rock or Church Cemetery, probably one of the most curious and controversial sites in the city.

With the Nottingham Enclosure Act of 1845 came the loss of land. In order to compensate for the loss of open space created by this act, the city council set aside over 130 acres of land for public parks and amenities. By 1850, the population of the city had grown and along with the need for new housing came the need for other services, one of which was the provision of new burial grounds. Plans were drawn up for a new cemetery to be built on some of the land set aside in 1845. The new burial ground was to be called Church Cemetery and plans included catacombs cut into the natural rock and a large new church which would have rivalled anything in the city. The land chosen for the new enterprise, described as '... a bare and barren hill,' was part of a sandy ridge running roughly east–west and the land known as Gallows Hill. The cemetery, designed by the then Mayor Edwin Patchitt, a local solicitor and clerk of the Cemetery Company, took several years to build and was not yet finished when it was opened in 1856. By this time money for the project had run out and the planned new church was never built. A mortuary chapel was added in 1879 in its stead. The city council took over responsibility for the cemetery in 1965 and it remains in their ownership.

A nice little story connected with the cemetery involves Mayor Edwin Patchitt and the Revd Dr George Oliver. Oliver was a prominent Freemason and ammeter Antiquarian. During the construction of the Cemetery, Oliver wrote series of seven open letters to Patchitt in an attempt to convince him that a group of curious caves on the site of the cemetery were in fact a Druid temple. Patchitt was unconvinced and the cemetery construction carried on resulting in the loss or permanent damage of many of the caves.

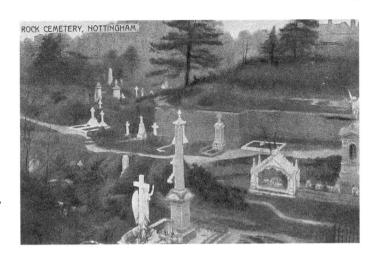

Church (Rock) Cemetery,
Nottingham, *c.* 1906
(photograph credit: The
Paul Nix Collection).

Oliver went on to publish the letters as a booklet called 'Shadows Departed', which was followed by an anonymous booklet called 'A Guide to the Druid Temple'.

There are indeed a complex of large caves in the cemetery. These, together with the remains of Oliver's Druid Temple are located in a three-sided hollow of cliffs running parallel to the road. One of these caves on the south-west side of the hollow is said to be the result of sand mining. However, its name, Robin Hood's Stable and attached folklore tell a different story. It is said that Robin and his outlaw gang of Merry Men used this massive cave (which can't be seen from the road), to stable their horses (hence the name). From here they could ride out and ambush wealthy travellers on the road. One day, while sheltering in the cave, Robin sent one of his most trusted men, Will Stutly out to spy in Nottingham. However, Will was somehow captured by the sheriff's men and sentenced to death. He was about to be hung on the Gallows Hill gallows when in the nick of time Robin rode out from the cave to his rescue.

'Robin Hood's Cave or
Stables located within
the site of the Church
(Rock) Cemetery
(photograph credit:
Joseph Earp).

Other caves, catacombs, were cut into an artificial depression called St Ann's Valley. The plan for these caves were to make them into a grand burial site for the wealthy residents of the city. The area was never completed as the cemetery company ran out of money and the rest of the grave plots were used as paupers' graves. None of the caves are open to the public as for many years they have been deem to be unsafe. However, it is possible, and well worth a visit, to enter the realm of Oliver's Temple and walk its central serpentine path from where the mouth of Robin Hood's Stable and the catacomb tunnel entrance to St Ann's Valley can be seen at close quarters. It is a simple matter to walk through the gates and take the side path which runs downhill parallel to the boundary fence against the road. At the bottom, the path turns back on itself and enters a hidden secret world where, on a still autumn evening, you might swear you have seen the fleeting glance of the robed shadow of a Druid gliding between the gravestones. Please be mindful that the cemetery is still consecrated ground.

The Forest Recreation Ground: Looking down (north and west) from our lofty vantage point the adjacent green space is the Forest Recreation Ground, or the Forest as it is affectionately called. It takes its name from the fact that, like the rest of the area, it was once a part of the medieval Sherwood Forest, (in fact, it was the Forest's southernmost boundary. With the Enclosure Act of 1845 came the need to retain green spaces for public use as parks a recreation. At the foot of the north slopes of the line of hills we now stand on, the Forest is defined as a long rectangle of level ground. This area of land was used as a horse-racing track until 1773 when it was officially adopted as the Nottingham Racecourse. The racecourse continued in use until, as part of the development of the recreation ground, it was moved to Colwick at the end of the nineteenth century. Over the years the Forest has been used for many sports including cricket and football. A good example of the latter is the fact that the Forest was the first home of Nottingham Forest FC after they were first formed in 1865.

The area of caves in Church (Rock) Cemetery known as St Ann's Valley (photograph credit: Joseph Earp).

View of the 2012 Goose Fair taken from the top of the Forest Recreation Ground (photograph credit: Joseph Earp).

Nottingham's Goose Fair: Perhaps the Forest best claim to fame is the fact that once a year, it has continually played host to Nottingham's Goose Fair since 1928. It was in that year that the fair was moved from its traditional home at the Old Market Square, having over the years, physically out grown the site.

The Goose Fair is widely acknowledged as being the oldest and largest 'mobile fair' in the country. Dating back to 1284 the fair has been held every year, except during the seventeenth-century plague and the First and Second World War. Originally a trade event, since the nineteenth century the fair has become associated with the many rides and food stalls. The name 'Goose' dates back to its medieval origins when it was a Michaelmas Fair. Roast goose was a traditional meal at this time of the year (late September) and many thousands of geese were brought into Nottingham from Lincolnshire and the Fens to be sold at the fair. Here's the secret of how to always to have enough money to pay your debts an old rhyming couplet goes: 'He that eats goose on Michaelmas Day, will not lack money his debts for to pay'.

Recommended Places to Visit

At this point, our trail is officially over. However, before we move back into the city via a few recommended sites we have one last secret hidden treasure close by that we recommend you to visit:

St Ann's Allotments: The Allotments are the oldest and largest area of Victorian detached town gardens in the world and has been listed with a Grade II by English Heritage. The site covers 75 acres and has been in continuing use for the last 600 years. The Allotments have a visitor centre (with café) providing information about this historic site.

St Ann's, from which the allotments takes its name, is an historic area of the city, which in its turn takes its name from the ancient spring known as St Ann's Well. In times past it was deep in Sherwood Forest to the north east of the town and was reached by a track off the Mansfield Road – now St Ann's Well Road.

The well, which was reputed to have had healing powers, was first mentioned in 1301. Close by the well was the house of the Wood Ward, an official who was appointed by the Crown to manage the valuable timber resources of the forest. It was also the duty of the Wood Ward to entertain the king and his men while they were out hunting in the forest. The well became particularly popular as a royal spar and the whole site rapidly became a favourite resort for the people of Nottingham including the mayor and Corporation who would, along with a procession of townsfolk, annually visit the well on May morning.

After the springs 'overflow' was contained by a culvert, in 1856, Marriott Ogle Tarbotton designed for the city council, a monument to mark the site of the well, built at the cost of £100. The well continued to be used until 1887 when all buildings in the area were demolished to make way for the long anticipated Nottingham Suburban Railway and it was believed that the monument and well were covered by one of the supports for the Wells Road Viaduct. In 1987 the site of the St Ann's Well was believed to have been discovered in the Gardener's Public House car park. This site was privately excavated by Mr David Greenwood and the results subsequently published in 2007 in the publication *Robin of St Ann's Well Road*.

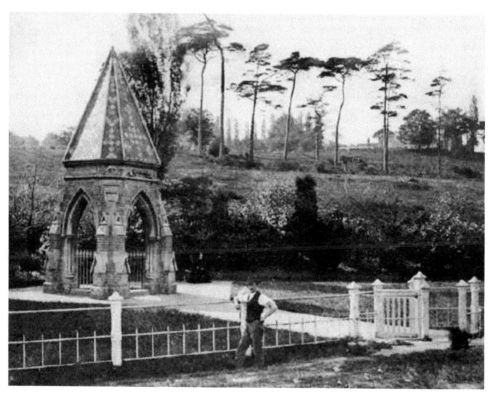

St Ann's Well *c.* 1860 (photograph credit: The Paul Nix Collection).

Since 2014 one of the latest attraction is an approximately quarter-sized replica of a turf-maze known as the Shepherd's Race which has been 'cut' at the front of the visitor centre. A turf-maze or more correctly a labyrinth is a path cut out of the turf which, after many twists and turns, spirals into and back out of a central point. The original Shepherd's Race was once one of the ancient wonders of Sherwood Forest.

The original Shepherd's Race was on Blue Bell Hill – Thorneywood Mount, not too far from the well. The hill was part of Sneinton Common, given to the parish as 'common land' by the Pierrepont family. It is described as being 34–35 yards across, covering an area of 324 square yards, with a single path 535 yards long. These proportions make the Race one of the largest examples of its kind in the country. Its design is fairly typical of the medieval labyrinth, with the addition of four rounded extensions or bastions. Each enclosed a small mound with a design known in heraldry as a 'cross-crosslet' cut into the top. The bastions are said to have aligned with the four cardinal points of the compass.

The purpose of the maze seems to have been to run, dance or walk the path to the centre and back out, possible without a pause. This was known as 'treading the maze' and was popular amongst visitors to the well. Following the Enclosure Act, the maze was ploughed up and the area planted with potatoes on 17 February 1797.

Visit the allotments and the replica Shepherds Race to try your hand at 'treading the maze'. The visitor centre and grounds are open to the public on specific days and they do hold various events throughout the year. As the allotments are still a working site we strongly advise checking with the allotments website and contacting their team before visiting. St Ann's Allotments Visitor Centre, No. 121 Ransom Road, St Ann's, *Nottingham*, NG3 3LH.

The 2014 replica of the Shepherd's Race located at the St Ann's Allotments Visitor Centre (photograph credit: Mo Cooper/STAA).

Nottingham Arboretum: Located not far away from the Forest Recreation Ground is Nottingham Aboretum. Again like the Forest, it was created from the Enclosure Act of 1845. The Arboretum was the first public park of its kind to be created in the city. It was designed by Samuel Curtis and officially opened to the public on 11 May 1852. There are many interesting features for the visitor to explore here, including; the aviary, the Chinese bell, the bandstand and a few notable statues. The park is host to several events throughout the year and is open seven days a week to the general public. Within easy walking distance of the city centre, the park has four entrance points: Waverley Road, Arboretum Street, North Sherwood Street and Addison Street.

Nottingham General Cemetery: To the south of the Arboretum, on the opposite side of Waverley Street, is a small entrance gate to Nottingham's General Cemetery. Now a closed cemetery, it dates to 1836 when the Nottingham General Cemetery Company was set up by an Act of Parliament. The company purchased 12 acres of land for the purpose of building a new municipal cemetery at a total cost of £5,885 for land, buildings and a chapel of rest. The main entrance to the cemetery is from Canning Terrace, on Canning Circus. Here is a gatehouse flanked by almshouses (all Grade II listed) which were designed by S. S. Rawlinson. In 1856, the Nottingham Enclosure Act provided for the addition of more land to the lower eastern side of the cemetery, and a new entrance lodge and chapel for 'Dissenters' were built. The cemetery is worth a visit to view some of the notable burials it contains as well as enjoying the local wildlife within the cemetery itself.

Waverley Street, Canning Circus, General Cemetery, 1841 (photograph credit: The Paul Nix Collection).

A Few of Nottingham's Not-so-Secret Sites and Sights

We now arrive in what is perhaps the city's most celebrated area for tourist and visitors, that around Nottingham Castle. It is no secret then that the castle and sites we include here are also the most written about in Nottingham and we would add little to the value of this book by adding secrets that have already been told.

Nottingham Castle: Many visitors to the castle will be disappointed to see that the original medieval castle no longer exists. Demolished as the result of the Civil War a ducal mansion was built on the site of the castle between 1674 and 1679 by Henry Cavendish, 2nd Duke of Newcastle.

If you can get over this initial disappointment, Nottingham Castle Museum and Art Gallery (NG1 6EL) – operated by Nottingham City Council – is a worthwhile place to visit. Although there is little remaining of the medieval castle, the museum and grounds tell its story, along with that of Nottingham very well (look out for the short film on the castles history, a must see). Alongside the permanent exhibitions, including one on our Robin, the museum runs temporary exhibitions, shows and events to suit all tastes (including an annual beer festival and a medieval jousting contest).

A tour of the Castle Rock Cave is an experience that cannot be rivalled by anywhere else in the country. This is what the museum's own website says in promoting the tour:

Beneath Nottingham Castle a labyrinth of man-made caves and tunnels continue to tell the turbulent story of this historic site Enjoy a memorable tour discovering the secret passageways, King David's legendary dungeon, the Duke of Newcastle's Wine Cellar or Mortimer's Hole.

However, a tour of the caves may not be suitable for everyone, especially for the less able: 'With some of the caves dating back to medieval times, the tour is strenuous with over 300 steep steps. However, for those who wish to descend through hundreds of years of history the tour is a must'.

The Park Estate: To the west of the castle along the same sandstone ridge line, are the grand houses of the Park Estate. Before the houses, this land, as the name suggests was the Hunting Park and fish ponds of the medieval castle. The Park, notable for its splendid Victorian architecture, is a private residential housing that began life in 1820 under the 4th Duke of Newcastle-under-Lyne. Development continued under the 5th Duke, who appointed architect Thomas Chambers Hine to design many of the houses. The area is lovely to walk around especially in the summer months.

Brewhouse Yard: Brewhouse Yard Museum (NG7 1FB) lies between the foot of Castle Rock and the old bed of the River Leen (Castle Boulevard). There have been buildings on this 2-acre site since at least 1217 when it is first mentioned in royal papers of Henry III. The reference to the 'repairs of mills' on the site, indicates that not only were the mills in royal ownership but that the River Leen, which in a considerable feat Norman

The Park Estate, 2012, known for its many fine Victorian buildings and houses (photograph credit: Joseph Earp).

engineering was diverted at Lenton, provided water not only for both the castle and the town but also powered more than one mill.

The real secret of this site are the large and spacious caves behind the façade of the current red brick building, caves, which like everywhere else in the town were used to brew and store ale. The name, Brewhouse Yard did not become attached to the site until after 1680 confirming its use for brewing. Although it is likely that the caves were used for brewing and maturing the ale brewed for the use of the castle garrison living in houses around the yard long before this date.

The present buildings are known as the Rock Cottages and date from the seventeenth century. The buildings now house the Museum of Nottingham Life. The museum is currently only open on specific days and it is advised to check the city council's website for further information before visiting the museum.

Brewhouse Yard, 2013 (photograph credit: Joseph Earp).

Ye Olde Trip To Jerusalem: We come now to what is the most famous public house/tourist attraction anywhere in Nottingham, the truly world famous Ye Olde Trip To Jerusalem, or the Trip as locals call it. Why is it so special you might ask? Well, take a trip to the Trip yourself to find out, this is one secret that we are not going to tell you. We do however guarantee you an experience you will not forget.

Here are a few things we can tell you about the Trip. Proudly displaying the date AD 1189 painted on an outside wall, the Trip claims to be the oldest public house in the country. Its name doesn't mean what you think it means. In this case the word 'Trip' comes from an old word meaning to stop – as in to trip-up. So, who was it that stopped here on their way to Jerusalem? The date gives us the clue. It is in fact the date of Richard I's coronation. Legend goes that Richard I (Richard Coeur de Lion) stopped here on the way to the Holy Land during the Third Crusade. However, dates and real facts do not add up and resent investigations show that the Trip is not the oldest pub in the world and not even the oldest in Nottingham, that honour belongs to the Salutation of 1240. 200 years ago the Trip went under the name of The Pilgrim and right next door, against Castle Rock, was another old pub The Gate Hangs Well. What we do know is that there was probably some kind of ale-producing establishment on this Castle Rock site which could have dated as far back as 1189 or earlier, but it wasn't a public house. But, as they say 'why let the facts get in the way of a good story'. A visit to the Trip will soon have you conjuring up images of Richard the Lionheart and the lads stopping off here for a quick pint of good Nottingham ale on their way to fight the enemy.

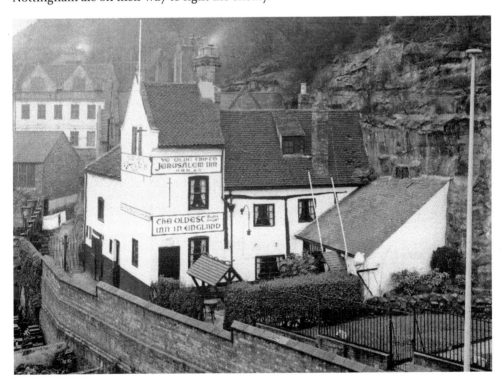

Ye Olde Trip to Jerusalem (photograph credit: The Paul Nix Collection).

City of Caves: Most of the caves in the city are unfortunately closed to the public. However there are a few exceptions: Nottingham Castle, Brewhouse Yard Museum, the Galleries of Justice Museum and for what is perhaps the complete cave experience, City of Caves in the intu Broadmarsh Shopping Centre.

Occasionally the caves at Lenton Hermitage and Sneinton Hermitage can be visited upon arrangement with the council. Several of Nottingham's oldest pubs are built over caves and are slowly getting the idea of opening them to the public, but it is again a matter of looking for advertised events. If all else fails where the caves are concerned, then we return you to the idea of refreshing yourself with a drink in the Trip!

Robin Hood Statue: Any book on Nottingham should, of course, include at least a mention of its most famous 'son' Robin Hood. Our book is to be no exception but we have decided to leave our Robin to the final pages. We all know the story of this famous outlaw and his Merry Men, he supposedly stole from the rich and gave to the poor. The history and origins of the famous character are shrouded in myth and as there have been many great works already written on him we will not attempt to add our own theory.

It is a sad fact and reality that not enough about Robin Hood can be seen in the city. The tales of Robin Hood no longer exist and not enough is made of him at the present museums. Perhaps the most popular site to find him is the Robin Hood statue, which is located on Castle Gate near the main entrance to the castle. On 24 July 1952, the statue of Robin Hood was unveiled by the Duchess of Portland. Gifted to the city by local businessman, Philip E. F. Clay, the impressive figure was intended to provide something tangible for visitors to see relating to Robin Hood, The 2.1 metre-high bronze statue was sculpted by James Woodford RA, a former student of the Nottingham School of Art, and made by Morris Singer & Co. of Basingstoke, Hampshire. It was estimated that it should

Robin Hood statue decorated with May blossom, 1 May 2013 (photograph credit: The Foresters Morris Men).

last for 6,000 years. The statue has become popular and it is one of the most famous photographed features in the city.

The Secrets Out

So there we are, the secrets are out. As someone once said: 'If only half of the history that has happened in Nottingham had happened in some other place, that place would be famous; but because it did happen here no one knows'. We hope this book has fulfilled its aim and revealed to the reader some of Nottingham's many secrets. Perhaps we have inspired you to learn more about Nottingham and you will actively go out and see the sights and sites included in this book. One last thing, don't forget, if you should wish to see us in person, 'We'll meet you by the lions!'

If you would like to know more about Nottingham's history we have included a bibliography at the end of this book. Alternatively you can visit our website – nottinghamhiddenhistoryteam.wordpress.com – where you will find plenty more information on the history of the city.

Acknowledgements

First and foremost gratitude must go to Nottingham's historians, archaeologists and antiquarians of past and present.

The authors are indebted to Alan Murphy of Amberley Publishing who made us aware of Amberley's Secret series and therefore, without him contacting us, this book would not exist. Special thanks go to all the staff at Amberley Publishing who have helped us throughout the writing of this book.

Finally we wish to express our gratitude to Lynn and Iris. Their support and especially their patience throughout the preparation of this book must be acknowledged.

Photograph Sources

The majority of the photographs in this book have come from the Paul Nix Collection and the collection of Joseph Earp. All other photographs included in this book have been clearly credited to the individual copyright holders in the photograph captions.

Every attempt has been made to trace and contact the original owners of all images used in this book where relevant. If copyright has inadvertently been infringed, copyright holders should write to the publishers with full details upon copyright being established. A correct credit will be incorporated into future editions of the book.

Bibliography

Beckett, J. (ed.) 2006, *A Centenary History of Nottingham* (Chinchester: Pillimore & Co. Ltd)

Blackner, J. 1815, *The History of Nottingham* (Nottingham: Sutton and Son)

Briscoe, J.P. 1884, *Old Nottinghamshire* (Nottingham: Hamilton, Adams and Co.)

Brown, C. 1896, *A History of Nottinghamshire* (London: E. Stock)

Deering, C. 1751, *Nottingham Vetus et Nova* (Nottingham: Gerorge Ayscough & Thomas Wellington)

Drage, C. 1999, *Nottingham Castle: A Place Full Royal* (Nottingham: Nottingham Civic Society and The Thoroton Society of Nottinghamshire)

Earp, F. E. 2014, *The A-Z of Curious Nottinghamshire* (Stroud: The History Press)

Earp, J. 2014, *Nottingham From Old Photographs* (Stroud: Amberley Publishing)

Earp, J. 2016, Nottingham Hidden History Team: nottinghamhiddenhistoryteam. wordpress.com

Lomax, S. 2013, *Nottingham: A Buried Past of a Historic City Revealed* (Barnsley: Pen & Sword Books Ltd)

Morrell, R. 1990, *'Druids and Antiquarians'*, *Hidden History*, No. 4, Volume 2, Pages 3-14. (Nottingham: APRA Press)

Nix, P. 1988, *A Nottingham Hidden History Team Monograph* Nos 1, 2 and 3: Nottingham Caves, Nottingham: APRA Press.

Thoroton, R. 1797, *History of Nottinghamshire*, London: J. Throsby.

Walker, J., 'An Itinerary of Nottingham', *Transactions of the Thoroton Society of Nottinghamshire*.

Waltham, T. 1992, *The Sandstone Caves of Nottingham,* (Nottingham: East Midlands Geological Society)